D1443882

3typ Skp

19.95
9 00

The Air We Breathe
Artists and Poets Reflect on Marriage Equality

The Air We Breathe

Artists and Poets Reflect on Marriage Equality

Edited by Apsara DiQuinzio
With essays by Eileen Myles, Martha C. Nussbaum, and Frank Rich

San Francisco Museum of Modern Art

The Air We Breathe: Artists and Poets Reflect on Marriage Equality is published by the San Francisco Museum of Modern Art on the occasion of the exhibition *The Air We Breathe*, organized by Apsara DiQuinzio and on view November 5, 2011, through February 20, 2012.

The Air We Breathe is organized by the San Francisco Museum of Modern Art. Major support is provided by the Teiger Foundation. Additional support is provided by the Annalee Newman Fund of The New York Community Trust, at the suggestion of John Silberman.

Copyright © 2011 by the San Francisco Museum of Modern Art, 151 Third Street, San Francisco, California, 94103. All rights reserved. This book may not be reproduced, in whole or in part, including illustrations, in any form (beyond that copying permitted by Sections 107 and 108 of the U.S. Copyright Law and except by reviewers for the public press), without written permission from the publishers.

"Let America Be America Again" from *The Collected Poems of Langston Hughes* by Langston Hughes, edited by Arnold Rampersad with David Roessel, Associate Editor, copyright © 1994 by the Estate of Langston Hughes. Used by permission of Alfred A. Knopf, a division of Random House, Inc. Reprinted by permission of Harold Ober Associates Incorporated.

"Angels in America" by Frank Rich, from *The New York Times*, August 14, 2010 © 2011 The New York Times. All rights reserved. Used by permission and protected by the Copyright Laws of the United States. The printing, copying, redistribution, or retransmission of this Content without express written permission is prohibited.

"A Right to Marry?" from *From Disgust to Humanity: Sexual Orientation and Constitutional Law* by Martha C. Nussbaum (2010) © 2010 by Oxford University Press, Inc. By permission of Oxford University Press, Inc.

Director of Publications: Chad Coerver
Managing Editor: Judy Bloch
Designer: Geoff Kaplan, General Working Group
Editorial Associates: Erin Hyman, Juliet Clark
Printed and bound in China by
Shenzhen Artron Color Printing Co., Ltd.
Color separations by Echelon

Distributed by D.A.P./Distributed Art Publishers
155 Sixth Avenue, 2nd Floor
New York, NY 10013

Cover:
D-L Alvarez, *You need a civil rights bill, not me*, 2011. Graphite and colored pencil on paper, 11 x 19 ⅝ in. (27.9 x 49.9 cm). Courtesy the artist; Derek Eller Gallery, New York; and Galería Casado Santapau, Madrid

Artwork Copyright and Photography Credits:
Copyright for each artwork reproduced in this book is held by the artist(s) and/or their representatives.
All copy photography by Don Ross except as noted below:
Pages 24–26: Photo by Joshua White, courtesy Regen Projects, Los Angeles
Pages 64–65: Courtesy the artist and Matthew Marks Gallery, New York
Pages 86–87: Ben Blackwell
Page 135: Courtesy the artists
Pages 166–67: Courtesy The Estate of David Wojnarowicz and P.P.O.W. Gallery, New York

Library of Congress Cataloging-in-Publication Data
The air we breathe : artists and poets reflect on marriage equality / edited by Apsara DiQuinzio ; with essays by Eileen Myles, Martha Nussbaum, and Frank Rich.
 p. cm.
 Published on the occasion of an exhibition held at the San Francisco Museum of Modern Art, Nov. 5, 2011-Feb. 20, 2012.
 ISBN 978-0-918471-86-4 (alk. paper)
 1. Marriage in art--Exhibitions. 2. Same-sex marriage--Exhibitions. 3. Arts, Modern--21st century--Themes, motives--Exhibitions. 4. Artists--Attitudes--Exhibitions. 5. Poets--Attitudes--Exhibitions. I. DiQuinzio, Apsara. II. Myles, Eileen. III. Nussbaum, Martha Craven, 1947- IV. Rich, Frank. V. San Francisco Museum of Modern Art. VI. Title: Artists and poets reflect on marriage equality.
 NX650.M29A39 2011
 700'.4543--dc23
 2011031009

Director's Foreword
Neal Benezra

———

The Air We Breathe breaks new ground for the San Francisco Museum of Modern Art in many ways. For one, in conception, it was a book before it was an exhibition. It is made up almost entirely of commissioned works and includes poetry in addition to a variety of works on paper. Most unusually, it asks the participating artists to respond to a single social issue, albeit one of the most pressing and divisive domestic issues of our time. Yet, in other ways, this highly creative project fits comfortably into SFMOMA's mission as a center for modern and contemporary art: to explore compelling expressions of visual culture. No matter where you stand on the subject of marriage equality, I think you will agree that the idiosyncratic, thoughtful, biting, or luminous expressions of the artists and poets in these pages are nothing if not compelling.

The nature of those of us who work at the museum is to view the world through art, and we encourage our visitors and our wider community to do so as well. At the same time, increasingly, our museum is a center for ideas. What happens to an idea viewed as art? It opens up, becomes filled with possibility; like the "air we breathe," it becomes fresh. San Francisco has been a base for gay rights since the movement's early days, yet here, as elsewhere in the country,

same-sex marriage can seem to be an idea with only two sides. This book and exhibition offer a multiplicity of sides, and a deeply human center, to the issue.

We are exceedingly grateful for the generous financial support that made this project possible. Major support is provided by the Teiger Foundation. Additional support is provided by the Annalee Newman Fund of The New York Community Trust, at the suggestion of John Silberman.

I congratulate Assistant Curator of Painting and Sculpture Apsara DiQuinzio, who conceived of the project and saw it through from start to finish. Elise S. Haas Senior Curator of Painting and Sculpture Gary Garrels provided valuable support for the initiative along the way. As always, the diverse talents of SFMOMA's staff brought the project to fruition.

But the real success of *The Air We Breathe* owes entirely to the artists, poets, and guest writers whose eagerness to contribute work to the project affirmed to us how relevant and crucial the discussion surrounding this civil rights issue is. I join Apsara in thanking them for their participation. Once again, they showed us that art is transformative.

Let America Be America Again
Langston Hughes

Let America be America again.
Let it be the dream it used to be.
Let it be the pioneer on the plain
Seeking a home where he himself is free.

(America never was America to me.)

Let America be the dream the dreamers dreamed—
Let it be that great strong land of love
Where never kings connive nor tyrants scheme
That any man be crushed by one above.

(It never was America to me.)

O, let my land be a land where Liberty
Is crowned with no false patriotic wreath,
But opportunity is real, and life is free,
Equality is in the air we breathe.

(There's never been equality for me,
Nor freedom in this "homeland of the free.")

Say, who are you that mumbles in the dark?
And who are you that draws your veil across the stars?

I am the poor white, fooled and pushed apart,
I am the Negro bearing slavery's scars.
I am the red man driven from the land,
I am the immigrant clutching the hope I seek—
And finding only the same old stupid plan
Of dog eat dog, of mighty crush the weak.

I am the young man, full of strength and hope,
Tangled in that ancient endless chain
Of profit, power, gain, of grab the land!
Of grab the gold! Of grab the ways of satisfying need!
Of work the men! Of take the pay!
Of owning everything for one's own greed!

I am the farmer, bondsman to the soil.
I am the worker sold to the machine.
I am the Negro, servant to you all.
I am the people, humble, hungry, mean—
Hungry yet today despite the dream.
Beaten yet today—O, Pioneers!
I am the man who never got ahead,
The poorest worker bartered through the years.

Yet I'm the one who dreamt our basic dream
In the Old World while still a serf of kings,
Who dreamt a dream so strong, so brave, so true,
That even yet its mighty daring sings
In every brick and stone, in every furrow turned
That's made America the land it has become.
O, I'm the man who sailed those early seas
In search of what I meant to be my home—
For I'm the one who left dark Ireland's shore,
And Poland's plain, and England's grassy lea,
And torn from Black Africa's strand I came
To build a "homeland of the free."

The free?

Who said the free? Not me?
Surely not me? The millions on relief today?
The millions shot down when we strike?
The millions who have nothing for our pay?
For all the dreams we've dreamed
And all the songs we've sung
And all the hopes we've held
And all the flags we've hung,
The millions who have nothing for our pay—
Except the dream that's almost dead today.

O, let America be America again—
The land that never has been yet—
And yet must be—the land where *every* man is free.
The land that's mine—the poor man's, Indian's, Negro's, ME—
Who made America,
Whose sweat and blood, whose faith and pain,
Whose hand at the foundry, whose plow in the rain,
Must bring back our mighty dream again.

Sure, call me any ugly name you choose—
The steel of freedom does not stain.
From those who live like leeches on the people's lives,
We must take back our land again,
America!

O, yes,
I say it plain,
America never was America to me,
And yet I swear this oath—
America will be!

Out of the rack and ruin of our gangster death,
The rape and rot of graft, and stealth, and lies,
We, the people, must redeem
The land, the mines, the plants, the rivers.
The mountains and the endless plain—
All, all the stretch of these great green states—
And make America again!

———

This book and the related exhibition evolve out of the belief that art, in both its visual and written forms of expression, generates and amplifies understanding. Art is a mode of responding to the world and a tool for communicating with others. At its most powerful, it can rupture entrenched ways of thinking, alter paradigms, and broaden discourse that seems resolutely fixed. As a culture we can look to artists to reframe issues and present them in forms that open doors to new possibilities—to produce novel ways of considering subjects rendered stagnant by outmoded models of thinking. One such matter in need of creative reflection is same-sex marriage, one of today's most pressing civil rights issues. We put this challenge to artists with the conviction that art can prevail where policy and prejudice have failed.

"Equality is in the air we breathe," wrote Langston Hughes in "Let America Be America Again." Written in 1938, the poem resonates still. An African American widely believed to have been gay, Hughes asserts, "There's never been equality for me." The poem is a powerful commentary on the racial discrimination that he experienced, but his observation of the exclusionary nature of civil liberties in the United States and his feeling of alienation would have been double edged. Although tolerance has grown since Hughes wrote the poem, equality still evades many American citizens. In 1967, the Supreme Court ruled in the case *Loving v. Virginia* that marriage was a fundamental right of all people, declaring: "The Fourteenth Amendment requires that the freedom of choice to marry not be restricted by invidious racial discriminations. Under our Constitution, the freedom to marry, or not marry, a person of another race resides with the individual and cannot be infringed by the State."[1] Almost forty-five years later, we have yet to extend to all persons the basic human right of marriage. Under current laws, same-sex couples are denied protections granted to opposite-sex

couples, including, in all but six states, the right to marry, hospital visitation rights, Social Security benefits, immigration and parenting rights, health insurance for spouses, taxation and inheritance rights, family leave time, and home and pension protections.[2] To refuse these rights to some individuals when they are granted to others is by definition discrimination, and as Frank Rich has eloquently stated in one of his many op-ed pieces on the subject for the *New York Times*, "It is hard to deny our own fundamental rights to those we know, admire and love."[3]

*

As of this writing, Connecticut, Iowa, Massachusetts, New Hampshire, New York, and Vermont, along with Washington, D.C., have enacted laws that permit same-sex marriage. In other words, only in these places is the fundamental right to wed protected for minorities. Since 2004, when Mayor Gavin Newsom first issued a directive to allow same-sex weddings to take place in City Hall, San Francisco has been a focal point for this issue. California was among the initial states to legalize same-sex marriage (the first being Hawaii in 1993, a decision that was amended in 1998); however, with the November 2008 passage of the ballot initiative Proposition 8, which reversed the California Supreme Court finding, same-sex marriage in the state continues to be a fraught issue. On August 4, 2010, U.S. District Court Chief Judge Vaughn R. Walker overturned Proposition 8 in the case *Perry v. Schwarzenegger*, and a stay was immediately placed on this verdict. In his eloquent ruling,

[1] Loving v. Virginia, 388 U.S. 1 (1967).
[2] For detailed information see the FAQ page on the website of the Human Rights Coalition, http://www.hrc.org/issues/5517.htm.
[3] Frank Rich, "Smoke the Bigots Out of the Closet," *New York Times*, February 7, 2010.

the George H. W. Bush–appointed Judge Walker concluded:

> Proposition 8 fails to advance any rational basis in singling out gay men and lesbians for denial of a marriage license. Indeed, the evidence shows Proposition 8 does nothing more than enshrine in the California Constitution the notion that opposite-sex couples are superior to same-sex couples. Because California has no interest in discriminating against gay men and lesbians, and because Proposition 8 prevents California from fulfilling its constitutional obligation to provide marriages on an equal basis, the court concludes that Proposition 8 is unconstitutional.[4]

The case is in the process of being appealed, and the U.S. Supreme Court is expected to rule on the matter in the near future.

The underlying motivation for this book resides in the desire to help generate awareness about the discrimination many citizens encounter on a daily basis before this case reaches the Supreme Court. We are at a pivotal moment where consensus is growing, but if, when the case ultimately reaches the court, the justices believe that cultural acceptance of same-sex marriage is not sufficiently widespread, there is a serious possibility of an unfavorable ruling in what is already expected to be a very close vote.[5] The project aims to foster an open, honest forum that frames the subject in a different light,[6] one that escapes the polarizing rhetoric

of the American political landscape and, in effect, expands the conversation on the subject, giving it greater room to breathe. It is my hope that it will act as a catalyst and provide a dynamic space for diverse forms of dialogue. In this sense, it is an activist project. The inclusion of gay, lesbian, straight, and transgender artists and poets is emblematic of the idea that this issue is not limited to a singular sexual orientation or identity. If one person's rights are suppressed, it is an affront to us all.

Although this debate focuses on same-sex marriage, it is important to underscore that the larger issue at stake here is LGBT rights more broadly. Certainly this country has made considerable advances in this domain since the Stonewall Riots in 1969 and the AIDS crisis. Significant recent examples include the overturning of the "Don't Ask, Don't Tell" law and Attorney General Eric Holder's announcement that the Obama administration will stop defending the 1996 Defense of Marriage Act, declaring it "unconstitutional."[7] Even prominent Republicans have come out of conservative closets to endorse same-sex marriage.[8] Yet it is clear that there is still substantive work to do. Acts of violence against those targeted as homosexual still occur all too frequently, in addition to consistently high suicide rates among gay youth. Moreover, on the international stage, legislation in certain countries, most notably Uganda, makes homosexuality a crime punishable by death. Discrimination still exists even in Congress: in 2010, the Catholic League and conservatives in Congress, including Speaker

* *

4 Perry v. Schwarzenegger, 704 F. Supp. 2d 921 (N.D. Cal. 2010).
5 See Michael Lindenberger, "Making a Supreme Court Case for Gay Marriage," *Time*, August 9, 2010, http://www.time.com.
6 To echo the title of an important precursor to this project, *In a Different Light: Visual Culture, Sexual Identity, Queer Practice*, an exhibition curated by Nayland Blake and Lawrence Rinder that took place at the University of California, Berkeley Art Museum and Pacific Film Archive in 1995.

7 Charlie Savage and Sheryl Gay Stolberg, "In Shift, U.S. Says Marriage Act Blocks Gay Rights," *New York Times*, February 24, 2011.
8 Those who have voiced support include Glenn Beck, Michael Bloomberg, Laura Bush and daughter Barbara Bush, Dick Cheney, Megan McCain, Ken Mehlman, and Ted Olsen. See also Sandhya Somashekhar, "Same-Sex Marriage Gains GOP Support," *Washington Post*, August 27, 2010, http://www.washingtonpost.com.

Introduction
Apsara DiQuinzio

of the House John Boehner, demanded the removal of David Wojnarowicz's 1987 film *A Fire in My Belly* from the exhibition *Hide/Seek: Difference and Desire in American Portraiture* at the National Portrait Gallery in Washington, D.C.—the first group exhibition of art to explore the evolving social perceptions surrounding sexual identity and desire in American portraiture. Wojnarowicz made his film shortly after his lover, Peter Hujar, died due to complications relating to AIDS (Wojnarowicz himself died of similar causes in 1992). The Smithsonian Institution bowed to the pressure, removing the film from the exhibition in an act of censorship that recalled the culture wars of the 1990s and resulted in an outpouring of protest from art communities. For this reason, we give Wojnarowicz the final word in this book, with his poignant work *Untitled (One day this kid ...)* serving as a coda.

These incidents are palpable reminders that civil rights for gays and lesbians need to be addressed on ever broader cultural levels. It is with this clarion call, to borrow Frank Rich's term, that *The Air We Breathe* assembles thirty visual artists and eight poets, from different generations and backgrounds, who offer their commitment and their best thinking to the cause of equality for same-sex couples through their original contributions. Each contributor was asked to make a new work and was encouraged to approach the subject in any manner that was true to his or her working method; in a few instances a relevant previously made piece was selected. We sought artists who often work in a political and social vein, many of whom were already addressing related issues in their practice. Certain recurrent themes surface throughout the contributions: love, equality, human connection, and a critique of normative definitions for domestic partnerships. Still, the styles and voices present here are intentionally diverse and multivalent. If the works have anything in common it is that they possess the ability to communicate on intimate and universal levels, and have the rich potential to be open-ended yet direct, imaginative, and thought-provoking.

A number of the visual artists incorporate a discursive approach, leaning on the directness of language and text. Carlos Motta has created an ambitious, wide-ranging project that includes an Internet archive and publication, titled *We Who Feel Differently*, for which he solicited and produced diverse texts, interviews, and ephemera that variously explore the history and development of the cultural and social issues revolving around sexual orientation and gender identity.[9] Jennifer Bornstein presents a typeset list of countries where, as of the year 2010, same-sex activity is punishable by law, noting in red the exceptions where it is legal for women only.[10] For Bornstein, the typewritten, outmoded style of presentation reflects the outmoded way of thinking that the laws perpetuate. Simon Fujiwara, a Japanese-British artist based primarily in Berlin, has dictated a letter to America in English from Plaza Santo Domingo in Mexico City, through a Spanish-speaking scribe who types letters for illiterate clients. Liam Gillick presents an incomplete pictographic alphabet for equality. Nearly halfway through, however, it becomes impossible to pair the pictures with their corresponding letters—a characteristic that mirrors the slippage between our written laws and our lived reality. Johanna Calle reformulates a typewritten feminist text by Lynne Segal on the development of sex roles in relation to the nuclear family.[11] Calle renders the text as a screen that delineates the silhouettes of coupled women. Their dresses recall the June Cleaver–like feminine archetypes of the mid-twentieth century, a time when the "role theory" discussed in the text had

*

[9] See http://www.wewhofeeldifferently.info.

[10] See Daniel Ottosson, "State Sponsored Homophobia: A World Survey of Laws Prohibiting Same-Sex Activity Between Consenting Adults," 2010 ILGA Report, The International Lesbian, Gay, Bisexual, Trans and Intersex Association, http://www.ilga.org.

[11] See Lynne Segal, "The Power of Sex Roles," in *Slow Motion Changing Masculinities Changing Men* (New Jersey: Rutgers University Press, 1990), 65–69.

popular appeal. Ann Hamilton culls a mesostic from the vocabulary surrounding the legal, social, and political issues of same-sex marriage. These words are then cross-referenced in three newspapers from one day. When there is no horizontal match in the papers the words appear in the center spine. Juxtaposed in relation to the print is a video still of two steel balls that are "balanced on a suspended surface - running into each other - shadowing each other - closing and widening the gap between them like two surfaces - touching - their movement embodies the dance of all relationships - coming together and moving apart."[12] Matt Keegan titles his two stacked-word collages *Sine Qua Non*, a Latin saying that roughly translates as "without which nothing." The words form the reiterative phrase "equal means equal." In the first collage, the words are aligned properly, but he has cut the word "qua" from "equal," signaling the beginning of its extrusion. In the second work, he renders "equal" empty, as the *qua*s lie in a mound at the column's base. The implication is that equality, a pillar of American idealism, is rendered meaningless without all of its essential structural elements; or absent, an echo of Langston Hughes's 1938 complaint, "There's never been equality for me."

Other artists have drawn on the power of pure visual expression to articulate their thoughts on the subject of marriage equality. Martha Colburn's enigmatic collage depicts two women in a medieval battlefield as they steal their last kiss before presumably meeting their imminent death. Using an iPhone app, Amy Sillman responded directly to Langston Hughes's poem by making dozens of bold, expressive drawings. The colorful images form a tumultuous stream-of-consciousness narrative relating to a host of human emotions surrounding life, love, breath, toxicity, pain, and

reconciliation. Erika Vogt's mystical print embeds instructions for printing and distribution into a sumptuous purple ground and beneath a weathervane symbol that metaphorically points north. (Eileen Myles in her essay perceptively likens it to a treasure map for equality.) Bogotá-based Nicolás Paris presents three abstracted motifs in his subtle collaged work about love in equilibrium: parallel lines (vows), a dove (peace), and a sphere (perfection). In his burned and stapled collage titled *Learning to Share a Sink*, Christian Holstad fuses the paper's material texture to its image, producing a riff on male domesticity—one that is humorous in its inventive banality. Sam Durant turns a map of the United States upside-down in an act of protest, delineating the tribal area of the Great Sioux Nation in spray paint—a phantom reminder of our complicated history concerning the recognition of minority rights.

Visual dyads recur throughout many works, as seen in the compilation of graphite drawings and found pages that comprise Colter Jacobsen's *The Boys' Book of Magnetism*. Raymond Pettibon poetically pairs two genderless hearts—united in medium, color, and form. On a page from a guestbook for one of his exhibition openings, Robert Buck playfully pairs a found drawing of a couple of roosters with an appropriated signature that he drew over it. Similarly, D-L Alvarez's graphite and colored-pencil drawing depicts an image of a lesbian couple from the 1970s on a motorcycle. Their self-assurance is emblematized in the work's title, *You need a civil rights bill, not me*, an excerpt from a 1966 speech in which Black Power activist Stokely Carmichael outlined that it was white people who needed the civil rights bill enacted in 1964; black people already know they are equal. Alvarez draws the parallel, implying that it is straight people who need enlightening in the ways and activation of democracy.

A number of the works represent gestures between lovers, in some cases actual and in others imagined. Elliott Hundley conceived of his intricate collage as "a valentine" to his boyfriend, Alphaeus Taylor, who appears in the small, incised photographs throughout the

*

12 Ann Hamilton, email message to author, March 30, 2011.

work. Taylor reciprocated by writing a song, the lyrics of which Hundley formed from letters cut out of magazines and pasted to the background. Both collage and song are titled after the book. A note Robert Gober scrawled in pen to his lover on a Post-it note echoes the wit of *The Daily Show*'s Jon Stewart, who regularly points to the hypocrisy in certain conservative behaviors, while simultaneously summoning the famous poem by the Protestant pastor Martin Niemöller from 1945:

> First they came for the Socialists, and I did not speak out—
> Because I was not a Socialist.
> Then they came for the Trade Unionists, and I did not speak out—
> Because I was not a Trade Unionist.
> Then they came for the Jews, and I did not speak out—
> Because I was not a Jew.
> Then they came for me—and there was no one left to speak for me.[13]

Shannon Ebner and Erika Vogt—artists who married in the state of California in 2008 while it was briefly legal to do so—contribute a rare collaborative drawing made for New Year's in 2005, calling it *LOVEREVOLVER*. At the time Vogt was interested in geometric forms in flux, and Ebner in palindromes. Andrea Bowers and Catherine Opie are not married, nor were they ever lovers; they are friends who attended Barack Obama's inauguration dressed as a married couple, and the photograph included in these pages shows them as they appeared in Washington, D.C., in 2009. Sharon Hayes penned two eloquent letters to an imagined lover for her larger body of work *Revolutionary Love: I Am Your Worst Fear, I Am*

Your Best Fantasy, which involved a series of performances in Denver and Minneapolis–Saint Paul during the Democratic and Republican National Conventions in 2008.

The eighteenth-century English poet Thomas Gray wrote that poetry is "Thoughts that breathe, and words that burn."[14] The poems that are interspersed among the color plates offer insight and rhythm to the project. As with the visual artists, a plurality of voices was sought in the selection of the poets. John Ashbery's poem points to the contradiction residing in our cultural inability to understand what we cannot even declare to be true. Dodie Bellamy and Kevin Killian interweave lyricism and social commentary in their jointly composed work, as they ponder language and normative behavior surrounding domestic partnerships. Anne Waldman incites the reader to see through the veil of false civil codes to the nature that lies beyond. George Albon's essayistic mode similarly addresses the conflict between what the body feels and what culture actualizes, while also gesturing to Hughes's poem. Will Alexander's ecstatic work reflects on cosmological forces of desire, pivoting around key historical espousers of moral certitude. Operatic, playful, erotic, and resistant, Ariana Reines's poem probes the social conventions that dictate behavioral norms. Dodie Bellamy has aptly written that Reines's response to the difficult task of writing a poem on this subject was to be "unapologetically herself."[15] In her contemplative poem, the late kari edwards rues the "spiritual drag" that life reinforces, and looks toward a metaphysical transcendence.

The artwork and poems do much of the speaking in the *Air We Breathe* project. The

*

*

[13] Many different translations of this poem exist. This citation comes from the website of the United States Holocaust Memorial Museum, http://www.ushmm.org.

[14] Thomas Gray, "The Progress of Poesy: A Pindaric Ode," The Thomas Gray Archive, http://www.thomasgray.org.

[15] Dodie Bellamy, *the buddhist* (San Francisco: Allone Editions and Publications Studio, 2011), 142.

essays in this volume, however, provide context and history for the themes these works articulate. Poet and writer Eileen Myles pens an expansive piece that helps to unravel the work of the contributors with insight, humor, nerve, and a probing criticality that is uniquely her own. Over the last two decades Frank Rich has written dozens of *New York Times* columns on same-sex marriage and equal rights. His steadfast voice on the subject has immensely enriched my own understanding, and serves as an important call to action for heterosexuals. As an expert on constitutional law, the philosopher Martha Nussbaum lucidly expounds on the subject of marriage equality in relation to the politics of humanity in her 2010 book *From*

Disgust to Humanity: Sexual Orientation and Constitutional Law. Included here is an adaptation from Chapter Five, "A Right to Marry?," which provides a thorough ethical and legal framework on gay and lesbian rights—one that articulates a vision of respect with dexterity and wisdom.

A Gallup poll recently found that a groundbreaking 53 percent of Americans believe that same-sex marriage should be made legal.[16] Polls have further indicated that the majority of people in California—the state that passed Proposition 8 by 52 percent—now favor same-sex marriage.[17] These signs of shifting attitudes are encouraging, but it is necessary to build on these achievements through the permanent

regularization of equal rights for every citizen. To echo the words of another poet, Gertrude Stein (who often referred to her relationship with Alice B. Toklas as a marriage): "To be regularly gay was to do every day the gay thing that they did every day. To be regularly gay was to end every day at the same time after they had been regularly gay. They were regularly gay. They were gay every day. They ended every day in the same way, at the same time, and they had been every day regularly gay."[18] Only Stein could impart glamour to the word "regular." It is our hope that this publication will buttress and enliven the regularization of equality, so that everyone can be regular, in his or her own regular way.

*

[16] See Alex Dobuzinskis, "Majority of Americans Support Gay Marriage," *Reuters*, May 20, 2011.

[17] A poll from the Public Policy Institute of California in March 2010 and a Times/USC poll in November 2010 found respondents supporting same-sex marriage 50 percent to 45 percent and 51 percent to 43 percent, respectively. *Los Angeles Times*, April 6, 2010, http://latimesblogs.latimes.com.

[18] Gertrude Stein, "Miss Furr and Miss Skeene," in *Selected Writings of Gertrude Stein*, ed. Carl Van Vechten (New York: Random House, 1946), 498.

My Gay Marriage
Eileen Myles

———

Several months ago I was invited to read a poem in a small alcove on the second floor of the gay community center in NYC—along with my girlfriend, Leopoldine, and many others, all of us as live adjunct to the Rainbow Book Fair. A rainbow, I should point out, isn't really such a *good* symbol. Such a goodie goodie symbol. Not in Mayan culture anyhow. A rainbow is a dirty bent bunch of colors, a bow. It's a troublemaker. And even as we entered the building we ran into some of our gay friends who had just read and they were grumbling on their way out. *Ugh*, really bad. Well too bad cause Leopoldine and I were just opening the door, getting on the elevator all ready to give it our gay best. When you are queer, gay, transgender, lesbian, fag, butch, you are routinely invited "in" to perform your queerness. To *be* it. Being gay is like joining the rodeo. It's a vague invitation, though the person inviting you never seems to think so. They think it's great that you agreed. You wind up wondering awkwardly which part you are willing to send out into the world. It's a

little like dressing your kid. This show invites a similar associative act, which is not so much here about *being* gay, but in light of the giant civil rights question we are all facing, what will the participating poets and visual artists and pundits and scholars be placing today next to that question? And of course the people in *The Air We Breathe* aren't all *homosexuals* but it is fun to search them on the Internet: is Ann Hamilton gay? She *looks* gay. If she were alive would Susan Sontag have put something in here? The show is simply asking the question if all these people, if Ann, if Susan, if Eileen, if Leo, if Colter and Bob have the right to publicly announce their love and *get answered*: You do. You go girl. Here's a blender.

It's so nebulous, this "gay" state. Have you seen the Tarkovsky film *Stalker*? In it a very butch-looking man regularly leaves his wife and kids to go to this other, toxic-looking land where he can have thrilling adventures. It's a gay thing, I believe, to respond to such inner promptings, to go to a place where the wild

things are. It could be a women's golf tournament, or a sleazy little bar over a bridge on the wrong side of town where reproductions of sad clowns in frames are hanging over by the bar. These wobbly singularities, the journeys to such places, are the shapes homosexuals participate in that begin explaining our oddness to us while it is forming and we are still deciding how gay our lives will be especially when we are young and confused.

At the Rainbow reading in the tiny alcove most people had sorted out the ironies of their gay performance, it was not a big problem, and some clearly had no ironies at all, they were screaming gay right out loud. For others it was a question of poetic lineage or the newest thing they wrote that had something to do with pussy, or dick. Or even being female. There was glee, elbowing and pronouncements and beauty. It was deliriously good. It had camaraderie. It was mixed.

I remember in the nineties when this gay writing conference occurred in San Francisco.

Out Write. It happened for several years but that first time was really exciting. And the famous gay male playwright was asked to come and take part in our event. To be the keynote. He got up to the microphone and he said I don't consider myself a GAY playwright. I'm not a GAY writer, I'm a writer. And then he looked out at the room. All those ordinary fags and dykes staring back at him. I'm sure they *knew* what he meant. He was being encouraged to pollute his specialness with his deviance and he said uh no, thanks. Unbelievably this same gay playwright was invited this spring to be honored at a gay literary award ceremony and he did it again. And you know—I get it. I understand Edward Albee's dilemma. Don't you. Here is a famous great man and he's being asked to, you know, roll in the mud with the other pigs. I mean come on, did modernism ever hang a *gay* show. And what is *this museum* doing? So the homosexuals of 2011 invited the big man again and there he stood and pulled a sock over his head and he went into a closet by himself in his

slippers and made a cocktail and turned up the teevee. He put his feet up on the chair. And he grinned. Boy did he ever grin. He did it all in the name of greatness. Greatness is not just gay he said. He wasn't just gay. Like us. That's what he did. And if someone had videotaped the entire thing and put it in a show and called it "Edward Albee" it would be beautiful and sad. And that's what I just did.

Cause SFMOMA is inviting us to put something else in the room. I'm looking at Elliott Hundley's dirty cowboy shirt, all old and salmony with little men standing about. It's a rectangle. It's a vista. It's an artifact. It's actually a collage pinned together with red thread and pearls. *The Air We Breathe* is the name of his piece and it's fitting that this beautiful sexy rag is the name of the show. It's like a book torn open, but organy.

You know, it just seems to me that visual artists have permission to do *anything*. I mean anything good. Poets have it harder so I'll write about them first. Poets are smarter than visual artists so we get punished for it. Every journalist on the planet (the quitters!), for instance, they like to mock us. But in me these poets have a friend. Someone who understands the difficulties in producing or composing a poem for a show about gay marriage. It's like watching the procession of poets (in time) each standing up next to the president-elect one cold day in January. How can a poet not be wreaty with a job like that. How do you not make a speech.

Robert Frost, at Kennedy's inauguration, was wise enough to use a marionette. ("My little horse must think it queer …") His poem was a readymade. Here watch George Albon perform a postmodern solution—he makes a speech for sure, an enquiry on the topic of gay marriage, but he also allows us to ramble with him as a way of picking the political up (like the little horse) and examining sex, love, the color of the light on the day when such a bond might successfully enter the world, and he ends his poem like one's honey going to work: "I am off to the world." George's shards are beautiful because he circumscribed his topic,

got distracted, lost, but never abandoned the *general* area, which is a poet's job. Albon knows how to climb a mountain. Look at the clouds, but keep moving.

Re: John Ashbery, I'll just say that any poem in which the word "monstrance" appears, I like. In Catholicism the monstrance is the host dressed for show. It, like poetry, only gets work at certain times of the year. And then the abbreviated feast, the host, turns into a peepshow. What does John mean here. His poem is called "Undeclared." And I think his poem is dragging its sorry butt through history, through the pain and abandonment of homosexuality past. He's not dwelling, but he's *been*, or as he says, Capisce? His poem insists on the experience of the communicant, and reminds us that if you look close the whole thing falls apart, here, the case against gay marriage. He ends this poem with an odd address to spruce up the view: "brilliant bun." I respect Mr. Ashbery's privacy, so I won't ask, whose? And why is only one bun available for inspection. It's less lonely to be two. Exactly my point, says John.

Ariana Reines often starts her poem at the highest pitch of too-muchness. In "I Do" she claims to have as thick a dick as Evo Morales. She's committing the terrible crime of alluding to the dick of a man, a world leader in fact, and also she cites the existence of her own dick, and not only that but invokes its fatness too and at this level of giddy absurdity she has managed to make us comfortable with what's possible in the world of her poem. Which begins high, like I said:

> Why shouldn't Kevin Killian
> Be able to marry the Bolivian
> President Evo Morales if he wants to,
> and still stay married
> To Dodie Bellamy too, why not? Evo
> Morales has a coke-can cock we used
> To say to each other after watching
> Democracy
> Now together, an old love and I….

So we've got Ariana and her lover, we've got Kevin and Dodie, a married couple (of

My Gay Marriage
Eileen Myles

queer writers), we've got Evo and his sister, a pairing that implies he's gay by the absence of another woman—wait, is gayness, like femaleness, defined by lack? Ariana girds herself with authority by installing her dick both in her myth about herself and in the poem. What she's asking of course is the great question, why is marriage between *two* people at all. The numbers, the very essence of both poetry and marriage, legal marriage, the numbers are themselves wrong. And she's right and now all the rest of it is just bouncing on the mattress.

I would suggest that Will Alexander be the next inaugural poet, or at least poet laureate. Will is like the windmill of American poetry. I read with him once and he went on for an hour and a half. Maybe not that long but really long. And he's great. I think he turned his force in the direction of passion here in the poem "On Osmotic Attraction." He asks "& so / how can the extrinsic regulate the feral?" That is the point. I applaud this incredible (I am not being facetious) example of Will's caring. He is not a gay man. But he understands the simple fact that sex cannot be regulated by the state. Neither can poetry but both come to us in peaks and valleys and he has constructed an elegant peak mid-poem in order to honor the occasion. If he were standing out there on a January day he would make the whole country pay attention, get sleepy, go in and out of the kitchen, snacking, while communicating that poetry is a right, and is with us all the time, the human need to, once we've got language, dream in it, eat in it, sleep in it, work and stand and make trouble in light of the time of our being.

I love the boldness of Anne Waldman to write prose. Or a prose poem, whatever in hell that is. Her title is spectacularly beautiful: "Over the Hiding of Shape of a Bed a Tilling of Fields." It's an amazing Steinian gesture, this title, which is the leash of the poem and you can read her piece in this book but I prefer to point and gasp at Anne's micro elegance (the sign of a true poet) and move on.

"[B]oth the living and dead surround the present has been." kari edwards is dead. She was a transwoman and a maestro of time *in her writing*. The line I just quoted does not scan in a linear sense but it's like a teeny little movie in which one word or the accumulation of a number of words is affecting the textuality itself and it, within a given sentence or phrase, virtually jumps track. Of course the present "has been." And language is the very means by which we mark time. Holding our heads up, marking our bonds in it: hands joined and screaming I do.

Kevin Killian and Dodie Bellamy are married (they are the queers in Ariana's poem) and they both used to and could be or are at the flip of a coin or the bending of a blade of grass, gay. Kevin is a onetime poet who went the long way around and now he writes them again and good ones, and Dodie is a fiction writer and a onetime poet who wouldn't bother to return I think because her fiction and her essays are such fellow travelers of poet society that for her to actually write a poem would be like stepping off time to ask it a question. I think it's not going to happen and if it did it would be bad for all of us. "Behold the Bride/ Groom" is the title of their poem. Which reminds me of John Ashbery's monstrance. It reminds me of what Martha Nussbaum says about the "expressive benefits" of marriage being the most desirable (and the most political) ones. We declare our vows publicly and the world says you do. We (humans) need that echo. Kevin and Dodie's piece asks close to its end: Can marriage make anybody straight. Their question is indeed about them. It's a coy performative. They actually had their twenty-fifth wedding anniversary this summer. That's a lot of something, though I don't think it's straightness. "I'm getting to thinking if she's coming at all" is their final question. And now I must ask: who is she?

On to the artists! Robert Gober's piece (and Gober is famously queer, *huge!*) is like a large-size Post-it. I'm not supposed to have a favorite piece here but this is it already. I'm shooting my lesbian wad right now. It's like me, like everything I stand for. It seems really tossed off:

It's like that
old Haiku
First they came for
 the gays
But I didn't know
 I was gay
So who gives a shit

It's hard to write about such a piece as this because it's all context. Bob is essentially sticking a Post-it on a museum but he provides context, explaining in a note that he is responding to Jon Stewart (I don't think he's gay) on *The Daily Show*, who was laughing at the hypocrisy of Ken Mehlman, the Republican National Committee chairman who worked AGAINST gay marriage during the Bush Administration but now today he's working *for* it. Let's face it. Ken Mehlman's just a hardworking gay man. Bob wrote the note originally so he would remember to tell his lover, who was away, about this. Let's look at that *Reader's Digest* windup: "First they came for the gays …" Don't you feel tired just to hear this wheezing platitudinizing cranky machine begin. Oh yeah Mr. Prairie Home Companion. All oppressions are similar. That's nice and safe. We are so grateful when the cliché takes a turn: "But I didn't know I was gay / So who gives a shit." That hairpin turn is so mad, so disgusted, so helplessly stoopid. It's watching the news alone when you really need someone to laugh at it with. That's what a gay marriage is. And this show *is* a gay marriage. Together you put enough things in a room that it alters the essential alkaline, the ions in the room. Edward Albee wasn't *alone*. He didn't forget he was gay. He just couldn't forget he was Edward Albee. I prefer the sadness and disgust of Bob Gober, the giant gay man, a boy, a child, who felt alone on the couch watching teevee—suddenly to find yourself in an empty institution, your apartment, the building, this town, without your gay marriage. Alone in America. Gay people don't want to be like everybody else. They want to be just like themselves. They want to be *home* for instance. I should go home. I'm working in

my studio but I am supposed to be moving in this week with my girlfriend and here I am up very late, in my old studio, worrying, writing about art, about gay marriage. Which is kind of an honor.

And I think Martha Colburn's battle landscape is the history we deserve. Black swords, decapitated horses, Tony Oursler mask heads on sticks, and a pair of medieval nurses dead center kissing. It's all patchy, stabby, arrows jutting from a horse's butt, but something else is won in this painting, a kiss between women that's at the center of no other fake old painting I know. Leopoldine pointed out when I showed it to her that this is our history. It's just that it hadn't showed until now. So it's more an *uncovering* than a drawing. D-L Alvarez has made a drawing of "Dykes on Bikes" into a techno banner. Curly-haired woman in glasses stares right through her time into ours and the plastic speed of abstraction on the right of the piece is erasing anything else the original photo might have meant. There's a celebration and an anti-ism. The title *You need a civil rights bill, not me* is spoken to us from the mindset of her thighs tightly clamped around a Honda with her pal on the back. Two times facing each other, it seems. To quote a poem here, George Albon's in fact: "as the surface crazes." That's what's answering her grin.

All of which reminds me of that four-way conversation I just heard on MSNBC about FEAR. It was a great new idea. Suddenly now that Osama bin Laden is dead we *notice* that we've been manipulated into The United States of Fear. Everyone's grinning. Four news guys. Finally it impacts on advertising, they conclude. We're even manipulated *here*. In America, in the media, they seem gleefully shocked to admit. Afraid your hands aren't soft, they begin incanting. Afraid you stink. All the men now are smiling. Suddenly you realize they aren't going to say afraid you'll lose your job. Afraid you'll lose your erection. No they are smiling about women's fears. This is the absolute lack of queerness. The absence of gay marriage. Until America can actually begin talking about his own gender well I think we will always be in a constant state of

My Gay Marriage
Eileen Myles

fear. We'll always be losing. It's how empires go down. In a state of total dishonesty.

I want to go home. So these are the wedding guests. Catherine Opie and Andrea Bowers in a photograph in suit and dress, both beaming. They're performing as a married couple at Barack Obama's inauguration but I also believe they are declaring their friendship. A light declaration or else a message of survival. We can't know. We have to look at their portrait with openness.

Robert Buck's "Mr. & Mrs. Richards" is funny. Two chickens strutting on their grid. It's never easy. That we slay animals without a thought. But to marry these two is comically holy. One chicken's having a thought. Maybe these are their vows: If it's art are we safe? "Mr. & Mrs. Richards." Their names, their eternal chicken names. It's no joke.

I could write a bible about Amy Sillman. Look at these. Pages and pages of them. It kills me! These are like phonemes, secret cells, peephole porn, strips of film, wild growth of organs, 'staches, muscles, and blobs. These are hieroglyphs. These are animated jean ads that suddenly scream foot, lung. There's kissing and noodling, eyes bleeding, ass-view bendings, product placement, semaphores, the knees of the Indian maiden on butter, heads in a porn theater kissing in front of the screen. These are big giant generous sheets, these are exhaustive, Kathy Acker–like, tiny bulbous sagas of life in all its radiant undying cartoonness. It reaches, it tugs, it pulls, it sings. Embracing, it bled. Ah-choo!

Laylah Ali's quick hug reminds me of how delicate genitals are. In the simple hues of this drawing the wet spilling nipples and spreading crotch fan out quietly, yet wildly like energy does. Eyes hold us, nostrils regulate us, but nipples and genitals communicate. When Nicole Eisenman does a portrait of her friends' relationship (*Celeste and Ulrika*) it's clear that one of the partners is a work of art. There's miscegenation here between maker and thing. I know that the two (Ulrika and Celeste) are part of a group that meets regularly and takes turns drawing one another, so objecthood is always a temporary position, or just a few weeks away.

No one minds if *these* people breed. When a child is born we will sell it! Nayland Blake's tree is not real. If you look closely its needles are too regular, more like screws. The tree is a double: as above, so below. The frost behind them reads like the treads of a wheel. I think of Pier Paolo Pasolini getting run over. Nayland's work always has more than one thing going on—back and forth, back and forth.

Carlos Motta's fonts go up and down, initially it was hard for me to wrap my mind around the meaning of what his all-text pieces are saying—"descralize democracy"? "Demoralize the judiciary"? Yet that is *exactly* what we need. We don't want to depress them, we want to get them out of the goodness business—though a big part of me thinks: if ever! If ever the goodness business wasn't utterly linked to the money getting moved behind the scenes. It's a plea. The tiniest bit of all in his work, *un milagro*, one teeny mid-point heart, is my very favorite part.

My friend Elinor, a Jew, tells me she judges people like this: would they hide me. The question I might ask about art is would I put it on my wall. Some drawings manage to exude a *vibe* and dailiness mainly. Even being a little anthemic, but not too much. Lily van der Stokker's drawing is not what you'd put in the kitchen over the stove, but high up on the wall in your office over your desk. This is spiritual art: RuPaul, Annie Sprinkle, La Cicciolina, Dolly Parton, Brigitte Bardot. This is her list. These are my friends. This is my house. This is my work. Come on in.

Colter Jacobsen's *Boys' Book of Magnetism* is elegant, found-seeming, placed. It is the perfect wedding gift. Colter's illustrations are six pieces of redly yellowing paper, the first being a magical tree practically spelling with its branches as it invites you into its (cough cough) gay world. For men (and a lot of dykes and transmen) "boys' stuff" does the task of reconnecting them to a lost Eden or to an emerging sexual place the way a box atop a dresser holds special things from "a time." The language of magnetism is so nineteenth-century naïf and laden with sexual innuendo. It's props. You want to gasp, go jerk off to the primness of these prompts. Come on

up, climb my tree. Next one reads STRANGE BLOCKS FROM STRANGE WOOD. One world opens from another, the blocks fitting, the fingers holding. Since when is eros geometric. Well, when it's queer. On the back of this sheet there's just a bit of script, in quotes: "if the only prayer / you ever sed whas / Thank You / it whas enough." The quotation marks at the end of the sentiment have the quiver and the excitement of exclamation points. The misspelling is him, whoever, at his best. He means it. There's a strange white diamond on the surface of the paper that you don't entirely see but you struggle to read the script against. Then, you turn the page and two male profiles are facing each other. Their eyelashes are so pronounced in silhouette. That's dirty. Speaking of which there's a tiny vertical stain on one of the faces from about the bottom of the eye socket to the lower cheekbone. Almost a scar, gray in the honey of the brown paper. Just a little butch. Imperfect. And what if Colter's straight? It's just not possible. Now we have a larger piece of unfolded paper, a faded neighbor I guess of the silhouettes, and these profiles are framed by the bright white lines of paper unexposed to sun, so here it's time/fold/time/profiles. Cumulatively, one gets involved in the objectness of the men represented, and our own relationship to seeing them, who they were, and the inevitability of everything precious getting lost eventually. Not my love! Now we get an open book with two men's faces, young men from the past. The face on the right's scarred by an embossed crest. That crest screams "family" in all its grotesquerie. Followed by two branches tied together oddly. The paper behind them is not only oranging but on its left edge it bleeds a red trim. That trim makes me groan with pleasure. Colter's piece is in effect a paean to "the closet." Layer upon layer of the love that dare not speak its name. Was Abraham Lincoln gay? We'll never know. But the question arouses us. And touches us deeply, if we feel safe enough, if we allow it.

I thought these buoys were Ann Hamilton's molars but in fact they are steel balls. Along with them she threw in one of her "concordances." I saw piles of them in St. Louis and now I realize I have ON MY BOOKSHELF AT THIS MOMENT the exhibition's takeaway kit!! From it I learn that a concordance is "a composition combining and harmonizing various accounts." It seems Ann and I are in the same business. We're like wedding planners. Her concordances represented "the *poetic* and physical presence of the project within the walls of the Pulitzer Foundation for the Arts." Poetic *here* means *these* are source words, chosen for this occasion, that form the basis for a search for phrases in the newspapers of the world. *Democracy, education, equal, equality, free, freedom, future, gay, giving, government, happiness, humanity, inequality, inheritance, institution, intimacy, justice, law, laws, legal, life, love, loves, marriage, mutual, open, out.* She's gay.

I think Matt Keegan's allegorical work reveals the falling leaves from the tree of equal. Doug Ashford offers pandemonium. Color; news. It's a place where there's no place to be. In Dan Perjovschi's cartoons there's a whole lot of penetration. I mean charts and icons that will help you get into the bathroom correctly and also the persistent penetration of rings by fingers. I think the problem of the state has eluded him and he must put *that* in his drawing. How to fuck it? Or is it fucking us. Or *won't!*

Simon Fujiwara's *Dir América* makes a kind of funeral monument to a dream of sexual liberation turned into an orgy in which he, the dreamer, was killed. I've had to sit with this one a while and it seems to offer a certain history of homosexuality and even a utopia of unbridled

My Gay Marriage
Eileen Myles

lust that has never been properly mourned. If the AIDS crisis and the whole history of violence towards homosexuals and transpeople in America is being put behind us by the acknowledgment of total citizenship that marriage, by implication, is offering, we still need a real funeral for all that was nonetheless lost. The people who are gone, the wasted divine sexual energy, unrealized, or punished or just stomped into submission. I love this bad-English dream of this wrong being righted. That someone in Mexico would transcribe this shattered dream for Simon (and us) is both poetry and the monument of it.

Allison Smith's puzzle ring just feels good. It looks sewn—is it? No, it's a collage. It's handsome interlocking rings of modulated rainbow colors—more native or earth-dyed than flashy corporate rainbow—and *should* be the folded textile invitation everyone receives in the mail for this show. Her piece is a communal wedding ring. I want to live in this land.

Jennifer Bornstein's alphabetic list of countries tells us where homosexuality is illegal: Ghana, Grenada, Guinea, Guyana, sometimes interrupted by a second status account in red type: female/female = legal or female/female legal in certain regions or = unclear, all of which turns out to be about women's right to have sexual relations with each other in these places. My sense was that in much of the world, like say in Russia (also not listed here), male homosexuality was always a crime until maybe recently whereas female homosexuality just never existed, though lesbians when they do exist are sent to mental hospitals. So to me, a lesbian, this list represents good news. Jennifer's like the wedding guest who "made" something. A female presence.

Erika Vogt's *Instructions, directions* is a bright watery purple marked by what feels like a jailhouse tattoo—a piratey diamond on a map is pointing towards a wobbly ancient N. Or N = X marks the spot. *Here.* It's this magical world that practically illuminates your face when you open it. And beneath its arcane surface are stealthily scratched "Spirit Duplicator Instructions," which are dull *and* intriguing in their literalness: set the dial to zero … tape the mascot to the drum / press the feed button / distribute. Can't even read it all but I'm ready. Are we *in* the machine? Erika's is such a great response to this show. To create yet another world. Like a hatch, a secret doorway into it.

Erika and Shannon Ebner's (and p.s. they're married) *LOVEREVOLVER* is kind of an imperfect palindrome like homosexuality. It *isn't* the same. The way "love" and "revolve" and "evolve" get echoey and subsume in each other materially. Their piece is totally word marriage. Erika drafts in (or probably they began with) a multidimensional set of lines: instructions for unfolding something, but then Shannon draws letters on the surface of the drawing actually defeating their own spatial illusion while creating a great ungay plaything. Or you could play it gay. Either way. One wants to push and prod and pop their piece. Sharon Hayes types up two bright documents in which she proclaims her love and is loved like an American woman who is continually told what to do, what not to do, who knows she is desired, is told she isn't, is told that her beloved does not know who she is, has told her mother to say she's not home, to leave no messages, is not to give any information out, and yet this woman who has felt all that cannot stop loving. It's a monumental piece and an ordinary one; in fact this whole damn book is just that. Like that reading in the alcove with Leopoldine was like being inside a strange and loving bell. It felt good. It was mixed. And that kept us paying attention. This is one brave show, *because* of its pulsing variety, not just some ornery rainbow.

Matt Keegan
Sine Qua Non #1 and *#2*, 2011
Letterpress prints with hand-cut paper
Each 24 ¼ x 18 ¹⁄₁₆ in. (61.6 x 45.9 cm)
Courtesy the artist and Altman Siegel Gallery, San Francisco

EQUAL
MEANS
EQUAL
MEANS
EQUAL
MEANS
EQUAL
MEANS
EQUAL
MEANS
EQUAL
MEANS
EQUAL
MEANS
EQUAL
MEANS
EQUAL
MEANS
EQUAL
MEANS
EQUAL
MEANS

E　　　　L
MEANS
E　　　　L
MEANS
E　　　　L
MEANS
E　　　　L
MEANS
E　　　　L
MEANS
E　　　　L
MEANS
E　　　　L
MEANS
E　　　　L
MEANS
E　　　　L
MEANS
E　　　　L
MEANS
E　　　　L
MEANS

QUA
QUA
JQUA
JA
JQUA
QUAMEANS
LQUA
QUA
QUA
QUA
QUA
QUA
QUA

Elliott Hundley
The Air We Breathe, 2011
Extruded polystyrene, paper, pins, string,
photographs, and plastic
48 ⅛ x 48 ⅛ x 8 in. (122.2 x 122.2 x 20.3 cm)
Courtesy the artist;
Regen Projects, Los Angeles; and
Andrea Rosen Gallery, New York

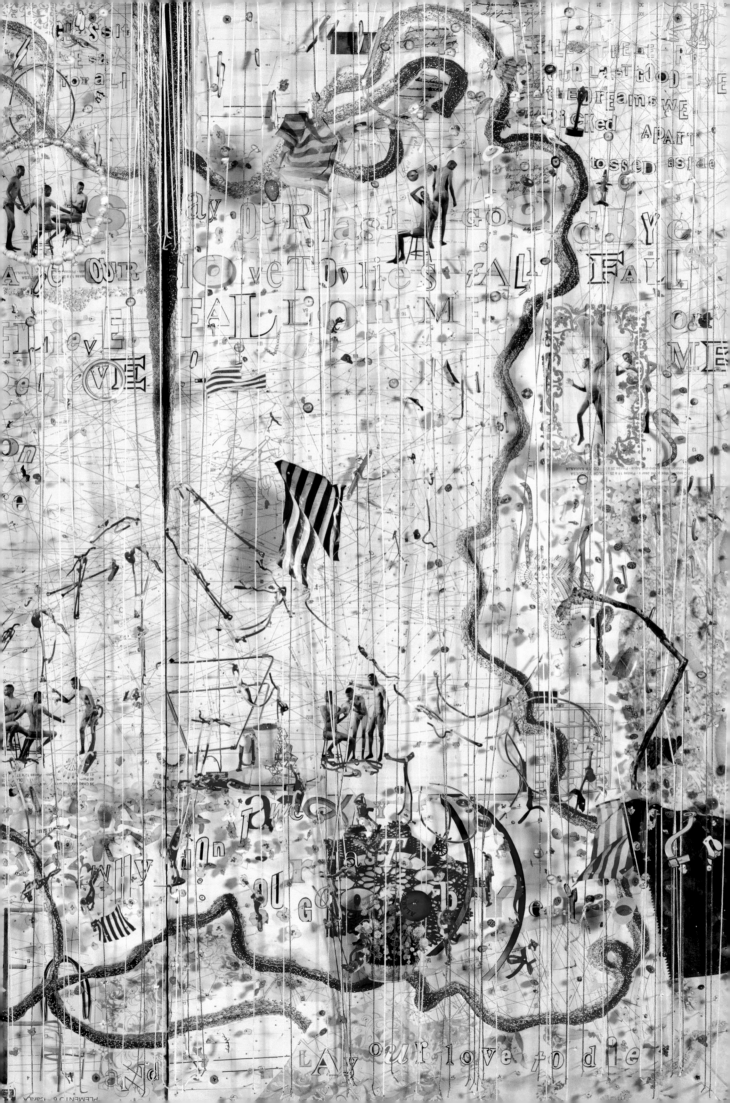

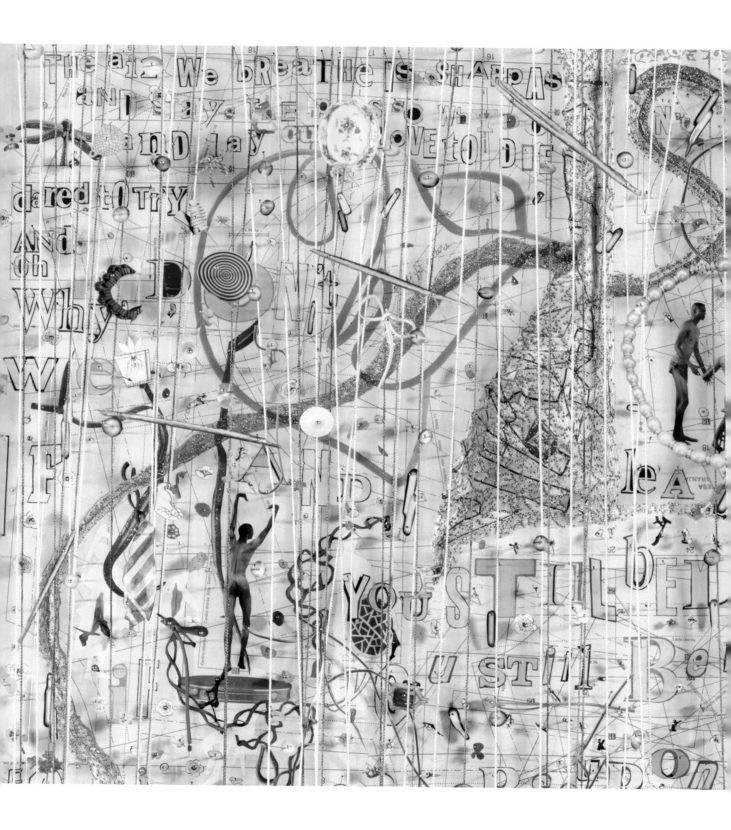

The Air We Breathe
Song written by Alphaeus Taylor

The air we breathe is sharp as glass
It stills the heart and stays the pass
So why don't we say our last goodbye
And lay our love to die

For all the dreams we dared to try
The picked apart and tossed aside
Oh why don't we say our last goodbye
And leave our love to lies

Fall
Fall on me … If you still believe (2x)

For broken oars upon her shore
The tempest torn
The weak and worn
Why don't we say our last goodbye
And lay our love to die

Jennifer Bornstein
2010, 2011
Typed ink on paper
11 $^{11}/_{16}$ x 8 $^{1}/_{4}$ in. (29.7 x 21 cm)
Courtesy the artist; Gavin Brown's enterprise, New York;
greengrassi, London; and Blum and Poe Gallery, Los Angeles

Afghanistan, Algeria, Angola, Antigua and Barbuda, Bangladesh, Barbados, Belize (female/female = legal), Bhutan, Botswana, Brunei, Burma, Burundi, Cameroon, Cook Islands (female/female = legal), Djibouti (unknown status), Dominica, Eritrea, Ethiopia, Gambia, Gaza (female/female = legal), Ghana (female/female = legal), Grenada (female/female = legal), Guinea, Guyana (female/female = legal), India, Iran, Iraq, Jamaica (female/female = legal), Kenya (female/female = legal), Kiribati (female/female = legal), Kuwait, Lebanon, Lesotho (female/female = legal), Liberia, Libya, Malawi (female/female = legal), Malaysia, Maldives, Mauritania, Mauritius (female/female = legal), Morocco, Mozambique, Namibia (illegal but not enforced), Nauru (female/female = legal), Nicaragua, Nigeria (female/female legal in certain regions), Oman, Pakistan, Palau (female/female = legal), Papua New Guinea, Qatar, Saint Kitts and Nevis (female/female = legal), Saint Lucia (female/female = legal), Saint Vincent and the Grenadines, Sao Tome and Principe, Saudi Arabia, Senegal, Seycheelles (female/female = legal), Sierra Leone (female/female = legal), Singapore, Solomon Islands, Somalia, Sri Lanka, Sudan, Swaziland (female/female = unclear), Syria (female/female = unclear), Tanzania, Togo, Tonga (female/female)= unclear), Trinidad and Tobago, Tunisia, Turkish Republic of Northern Cyprus (plans to repeal the law), Turkmenistan (female/female = legal), Tuvalu (female/female = legal), Uganda, United Arab Emirates, Uzbekistan (female/female = legal), Western Samoa, Yemen, Zambia (female/female = legal), Zimbabwe (female/female = legal).

Colter Jacobsen
The Boys' Book of Magnetism, 2011 (details)
Graphite on found paper
Dimensions variable
Courtesy the artist

THE BOYS' BOOK OF MAGNETISM

STRANGE BLOCKS FROM STRANGE WOOD

42

Undeclared
John Ashbery

So it is with the undeclared, the unidentified,
in streets unbecoming. Where we have a different expectancy,
premature at best. Prison saws, jelly
capsules, diamonds among the unrecyclables, monstrances,
scrapbooks get added to the mix. By mid-century none can say
who got here unaccompanied, where I'm going to love
till the cows come home. Capisce? What did you think I
said. He's a dandy though gregarious and at times others
will pretend to love us, screaming from most countries,
gunned down in an emergency, with a terrible cough.

This has been going on for some time, hasn't it?
I did not sleep well. Sky-nominated for the likely
reimbursement you're more than there now.
Morality sans religion dissolves at the seams, brilliant bun.

Shannon Ebner and Erika Vogt
LOVEREVOLVER, 2005
Printed ink and graphite on paper
8 ¼ x 9 ⅝ in. (21 x 24.5 cm)
Courtesy of Altman Siegel Gallery, San Francisco;
Overduin and Kite, Los Angeles; and Wallspace, New York

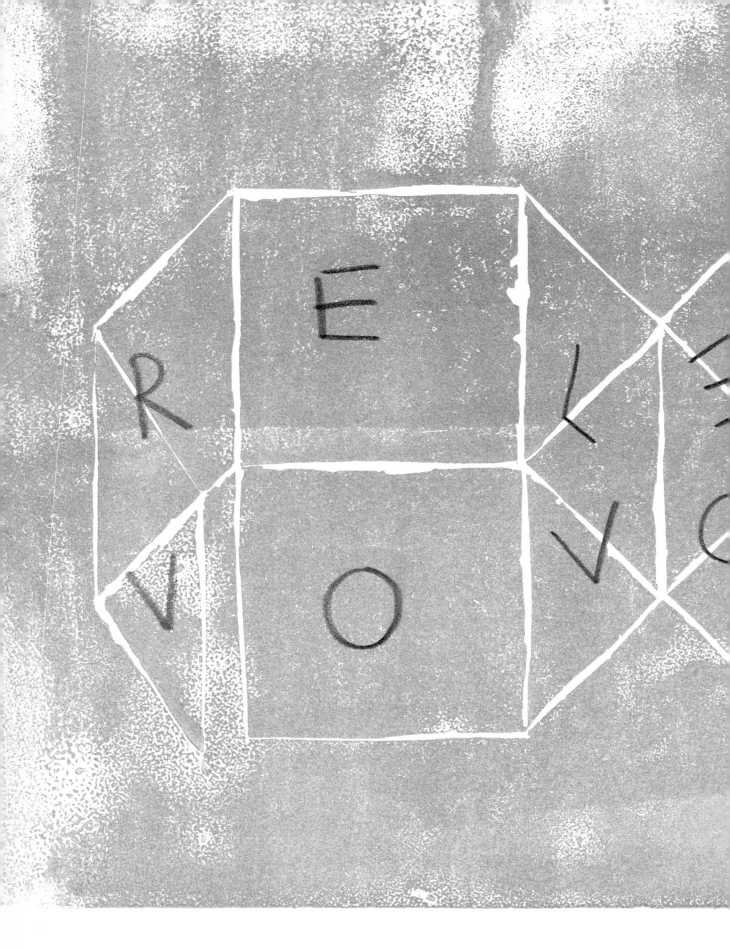

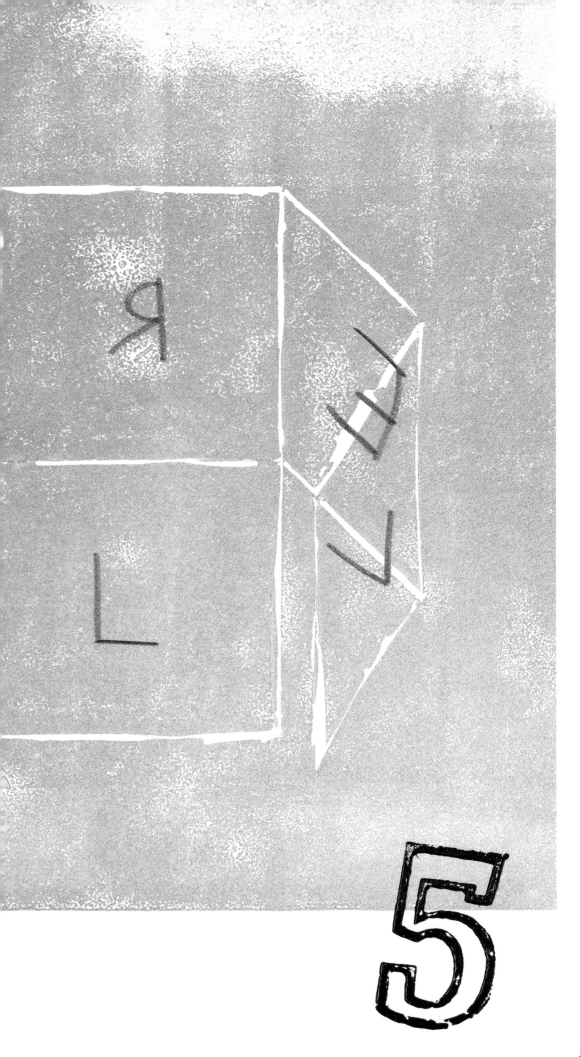

Sharon Hayes
Untitled from *Revolutionary Love: I Am Your Worst Fear, I Am Your Best Fantasy*, 2009
Printed ink on paper
Each 11 x 8 ½ in. (27.9 x 21.6 cm)
Courtesy the artist and Tanya Leighton Gallery, Berlin

My sweet love.

I know it's been a long time since we've seen each other and that this isn't
the best time to reconnect but I've been a mess since you left. I can't eat and
I can't sleep. I called your phone but your voicemail is full. I tried to reach
you by email but got an automated reply. I went to find you at the Pepsi Center
but I don't have a pass and there are police and party officials four lines
thick down there.

It's not like the old days, when things were loose and you could flirt or lie
your way in.
Yesterday your mother told me that you gave her explicit instructions not to
tell anyone anything about you. I saw a mention of you this morning in the
newspaper but there wasn't even the slightest hint of where you'd be today. Why
all the secrecy my love?

This convention makes me miss you more than ever.
This used to be our season remember?
From June to November…from stonewall to the election…from the queens to the
polls…you used to say.

The last time I saw you, you told me "the time is now" You looked so fierce and
so passionate. You were beautiful. "This is the moment to act," you said.
I was angry that you were thinking about the election when I was thinking about
us so I told you I was acting all the time and that I wasn't going to take to
the streets shouting unless we are shouting revolution.

Don't you remember, my sweet, when we were shouting revolution?

I know that you get mad at me for looking to the past but I can't understand
the present or believe in the future if I can't look back at where we've been.

In July we said we'd make it, if we could just believe.
In June they said we should wear proper clothes when we go out in public.
In May I remember you told a reporter that that I was expecting too much from
you and that I should remember how far we've come.
In April I told you "We become the enemy of our own liberation when we insist
that we are not oppressed."
In March I said, "I demand the right to be gay anytime, anyplace. The right to
modify my sex for free and on demand. The right to free dress and adornment.
In February you said I was too loud, too opinionated, and too gay.
In January you told me that it wasn't so easy to just end a war.
On New Year's Day we resolved not to speak.
On New Year's Eve you told me I was stuck in the past.
On Christmas I said the time is now.
In December you told me that I shouldn't let other people tell me what to say.
In November we talked about old patterns.
In October I asked you to give me another chance.
In September you said you needed a little more time.
In August we shouted our love from on top of the highest mountain.
That summer we decided to have a new start.
June 29th you declared that this is a historic moment.

Now you ask me to believe you when you say that one day we will be together
again.
You ask me to understand that things have changed. That one can't have
everything that one wants right away.
Be patient you say. We'll get there.
I've been so so patient my love?

When will we get there?
What will it take?

Should I work behind the scenes.
Tone down my shirts and take off the lipstick.
Do you want me to call off the urgency?
Be happy about what I've already got.
Trade my heels for flats and my sneakers for dress shoes, should I wear loose
fitting clothes and take off my ties?

I can say "it's personal not political."
But what do you mean when you say you don't ask and I shouldn't tell?

Can you really be a homosexual and not a faggot?
Can you love longer as a lesbian and not a dyke?
Do your kisses taste sweeter if you are gay and not queer?
Are you more attractive as a queen for an hour than trans all day long?

They say, my love, that history moves in waves, from deep troughs to high
crests.
Sometimes I think you are in one and I am in another. I want to find a place to
meet.
I want to ride your crest as far as it will go to pull us out of the deep
trough we've been stuck in for so long but it takes too much out of me.

You want me to say that our love is just like everyone else's.
How can I say our love is like everyone else's?
You are the land that I stand on. You appear and my whole world appears with
you.

I know you're here. I can feel you in the streets.
Out of the closets and on to the streets.
I need you.
I need you to change.
I need another revolution.

You may be holing yourself up inside those layers of people, but I know that
the ears are the only orifice that can't be closed.
I am an army of lovers, my sweet, and I want you to hear me clearly.

I love you.

You are in the air I breathe…along with racism and homophobia and war and
violence.
And I find a way to deal with that.
Why can't you handle all of me?
My private side and my public one, the times when I am quiet and those when I
yell and scream.

I refuse to give up the territory of my emotional expression.
And I want you to love all of me.

What a pleasure to feel indignant!
This is a beautiful revolution!

So much has happened my love and we are just at the beginning. We will evolve
as we get ourselves together and we are only at the beginning. We'll be gay
'ntil everyone has forgotten and then we'll be gay again.

My dear lover,

I know you will be angry at me for speaking to you like this in public but
you left me with no other choice. I called your phone but your voicemail is
full. I tried to reach you by email but got an automated reply. I still
have your mother's number from when you were visiting her last summer but
when I called she said she didn't know who I was. This morning I tried to
get into the convention to talk to you but I don't have a pass and there
are police and party officials four lines thick down there. It's not like
the old days, when things were loose and you could flirt or lie your way
in. I'm not quite sure what you're all so afraid of. What's with all the
armor? Are things really that bad?

When I couldn't make it in, I waited outside hoping to find you in the
crowd of people lined up to get in. I know that you were there. I felt
certain that you passed me but I didn't see you. You are indistinguishable
from all the others—the delegates, the media, the police, those smartly
dressed young volunteers. I can't find you anywhere in this mess.

Did you see me?

Maybe not.

I'm standing on the Capitol Grounds, on the green rectangle just below
Martin Luther King Jr. Blvd.

You must admit, my love, we've had a terrible relationship. You kiss me
long and hard but you never loved me. I tried to tell myself I would get
used to it. That comforting old myth about the body's ability to adjust is
just pure fiction. If that were the case, after all these years, I should
take to hatred the way a duck takes to water. But instead I've suffered
terribly.

As far as I can make out I've ended my relationship with you every three
months for the last 38 years. I resolved never to speak your name in
public, I speak bad of you to all my friends and I even refuse to
acknowledge that you exist. I promised you I would forget about you, if you
left me alone. But each time I banish you from my life, you manage by means
of entreaties, telegrams, letters, letters to the editor, the imposition of
your friends or of mine, to call me back towards you.

For years, I've tried to make sense of your behavior.

When you told me you loved me but would never speak my name out loud, I
told you I could live with the silence.

When you told me you would fuck me but would never take me home, I told you
I would be your rest stop lover.

When you called me a moral pervert on the floor of the Senate but then
whispered your apologies sweetly in my ear, I told you to use me as your
scapegoat.

But when you gestured to shake my hand and spit on me instead, I told you I
was the rage of all queers condensed to the point of explosion.
Huey P. Newton said "even a homosexual can be a revolutionary" and I'm
finding my revolution. I've been awakening with ideas and with energy; I'm

replacing the old stories with new ones. How it began, I don't really know. Where once there was frustration, alienation and cynicism, there are new characteristics in me. I am in a flow of love and I am showing it.

There is nothing easier than to burn with enthusiasm for some issue and to be ready to fight for it, when the very same idea has inflamed hundreds of thousands of others. There is even something suspect, something actively repulsive, in denying ecstasy, in denying that which directs the outbursts of the heart.

You may be holing yourself up inside those layers of people, but I know that the ears are the only orifice that can't be closed. I am an army of lovers, my sweet, and I want you to hear me very clearly.

I've found my voice and with it I scream, I love you.

I love you because when I say I do, you blush and bury your face in your clothes. I love you because when I throw you a kiss your body shakes, quivers and writhes in response.
I love you because I know my love causes your heart to skip a beat and sends shivers up your spine.

I love you. It may be shocking to you but I do and I will shout it as loud as I can manage. I love you and will do so until it hurts you or me or both.

After all, my love, we're all queer.

And if you find in what I am saying something of which you feel unjustly accused, remember that one should be thankful that there is any fault of which one can be unjustly accused.

What a pleasure to feel indignant! This is a beautiful revolution!

I demand, my love,

1. The right to be gay anytime, anyplace.

2. The right to free physiological change and modification of sex upon demand.

3. The right of free dress and adornment

4. That straight-thinking views of things in terms of order and comparison be resisted. A is not before B, B is not after A., 1 is not below 2 and 2 is not below 3.

5. That we stop making promises about the future, which we have no right to make and which prevent us from, or make us feel guilty about, growing and changing.

So much has happened my love and we are just at the beginning. We will evolve as we get ourselves together and we are only at the beginning. We'll be gay until everyone has forgotten and then we'll be gay again.

Raymond Pettibon
No Title (Paint fills them ...), 2003
Watercolor and ink on paper
32 x 30 ¼ in. (81.3 x 76.8 cm)
Courtesy the artist and Regen Projects, Los Angeles

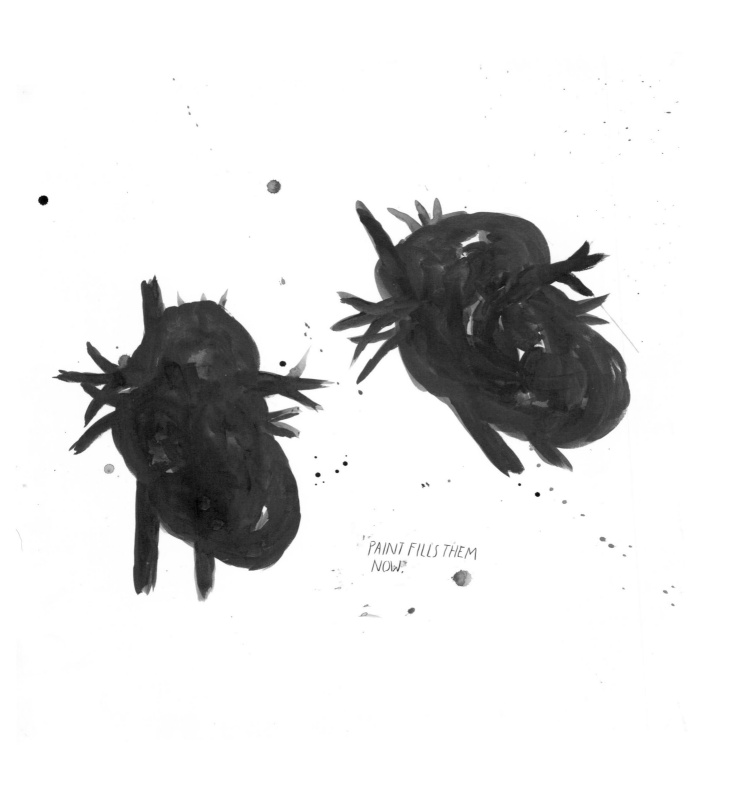

PAINT FILLS THEM
NOW.

Behold the Bride/Groom
Dodie Bellamy and Kevin Killian

Straight people who refer to their spouses as their "partners." The first time I heard this was when Tom Hanks won the Oscar for *Philadelphia*, when he thanked his "partner" (second wife Rita Wilson), as if the gayness of his movie role was bleeding into his life.

 White cherry flowers

 bleeding in the yard

 in the rain shower

I hear this partner business is rampant among academics, some of whom are careful to not reveal the gender of their mates, because it doesn't matter, because it "doesn't matter." Doesn't matter to whom?

 There is no whom

 and there is no other

 in the gender of the nightshade

In my experience, the first thing queers want to know about a person is where they fall on the gay/straight/other continuum.

 Philadelphia freedom

 bells ring on the shadowy grave of the other

Recently I'm hearing lesbians referring to their partners as their wives. Both of them are wives. I'm also hearing gay male couples referring to one another as husband.

It was like the old saying,

Mary had a little amulet,

its fleece was white as cherry

I'm wondering if there's a linguistic migration going on and in the future husband and wife will solely be queer terms, with partner reserved for straight marriages (similar to the way happy people, many straight, used to be gay).

I am my own bride, my own bridegroom,

for the one I love most lay sleeping by me under the same cover in the cool night,

—and that night I was happy.

I'm thinking of the woman who when we got married in 1986, said that we shouldn't do it, out of solidarity for the queers who couldn't marry. Was it wrong of us to marry?

Yes, very wrong, but spread the blame wide,

the state control of sexuality grows ever more stern,

and marriage like any other contract works for the state.

Does being married make you straight? Can marriage make anybody straight?

The waters roll to the shore, the cry of the people splits the rock,

What do you call me?

I'm getting to thinking if she's coming at all.

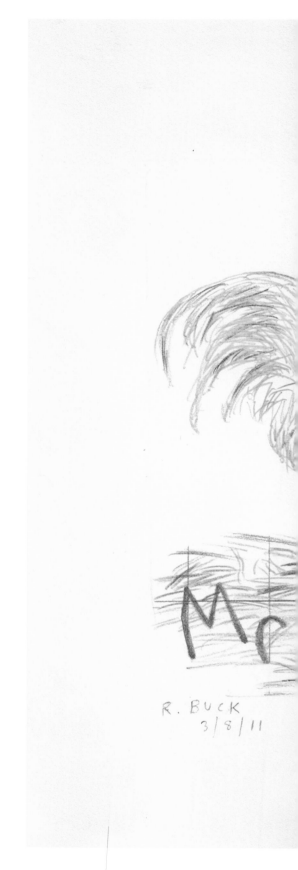

Robert Buck
Second Hand (Helen 11/20/89), 2011
Graphite on found drawing
8 x 10 in. (20.3 x 25.4 cm)
Courtesy the artist and CRG Gallery, New York

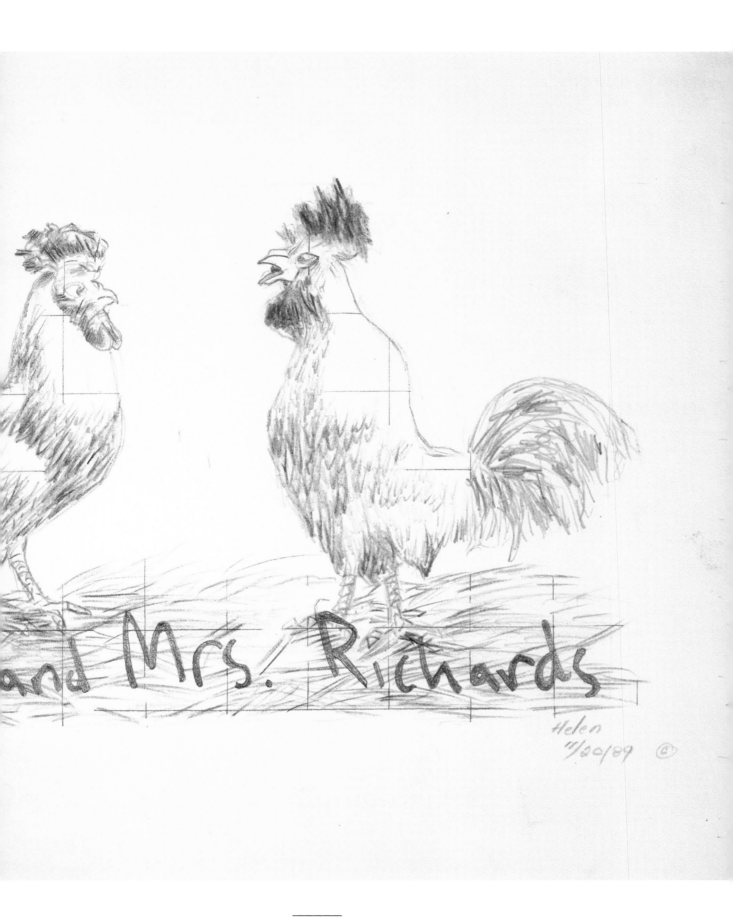

...and Mrs. Richards

Helen
11/20/89 ©

Dan Perjovschi
Untitled, 2011 (details)
Graphite on wall
Dimensions variable
Courtesy the artist

MAN ←→ WOMAN

CONTRACT

WOMAN WOMAN
LOVE
MAN MAN

D-L Alvarez
You need a civil rights bill, not me, 2011
Graphite and colored pencil on paper
11 x 19 ⅝ in. (27.9 x 49.9 cm)
Courtesy the artist; Derek Eller Gallery, New York;
and Galería Casado Santapau, Madrid

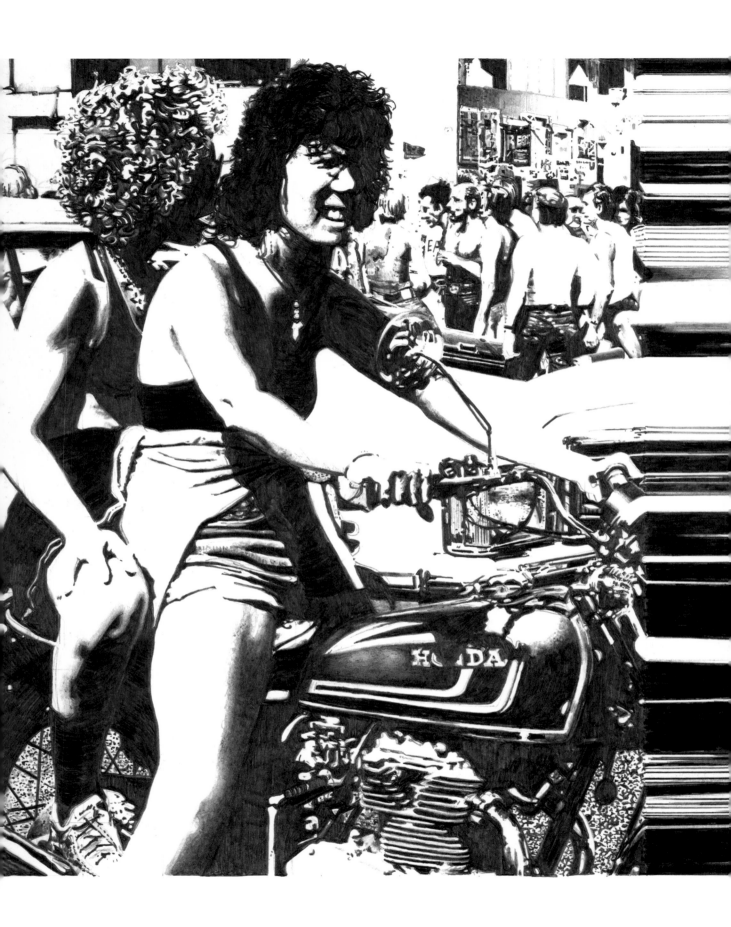

71

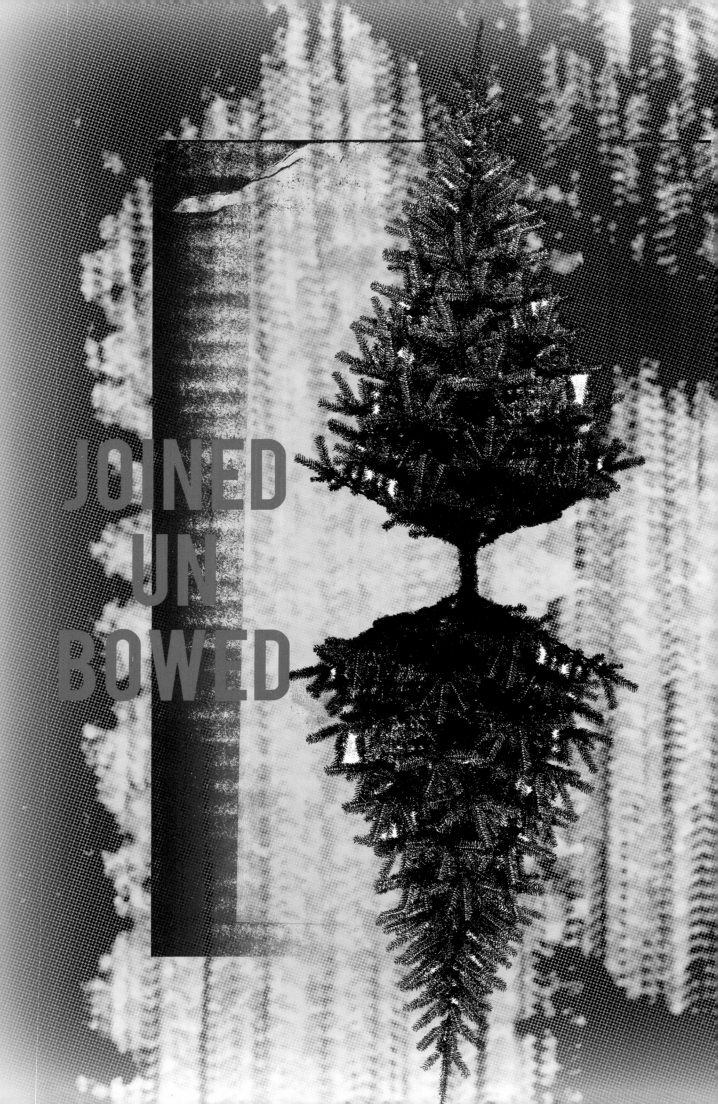

Nayland Blake
JOINEDUNBOWED, 2011
Inkjet print
19 x 13 in. (48.3 x 33 cm)
Courtesy the artist and
Matthew Marks Gallery, New York

Johanna Calle
Untitled (roles), 2011 (detail)
Typed transfer print on ledger paper
13 x 18 ⅛ in. (33 x 46 cm)
Courtesy the artist and Galería Casas Riegner, Bogotá

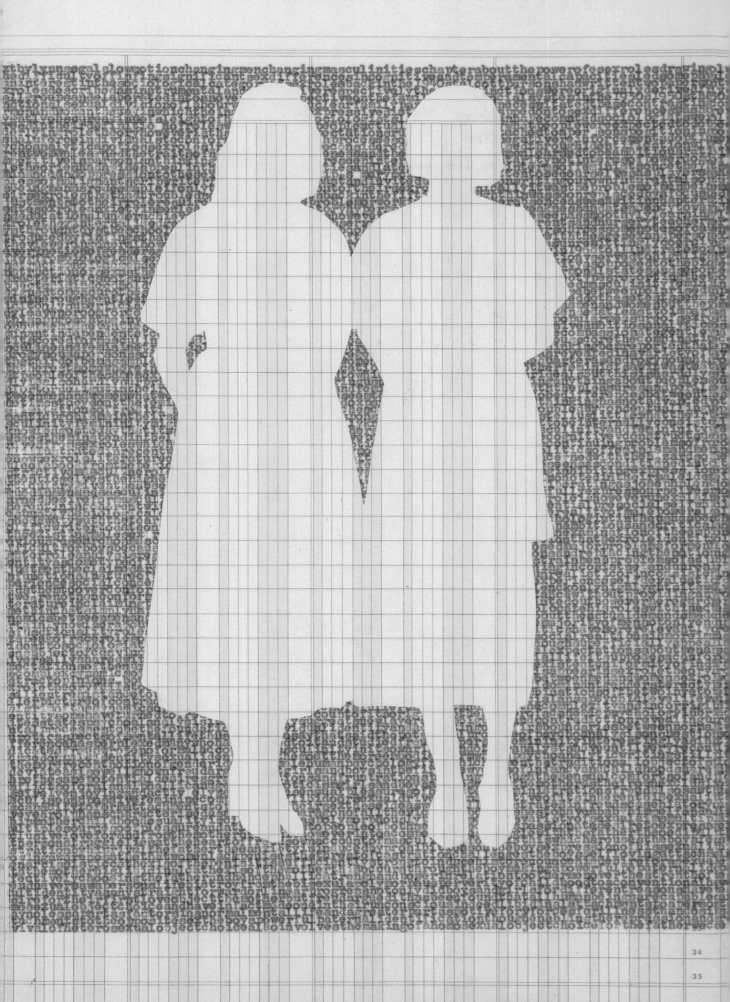

Over the Hiding of Shape of a Bed a Tilling of Fields
Anne Waldman

Intent upon joining color to color,
Working the bedclothes of many cloths.
—Robert Duncan

Start from a work of persons of sameness and not the same and rise up not like a veil of unsanctified tears, but rise up in sameness a work in love. Never unsanctified enigma if not but pure flow. And consent or rip in the veil which is constant sanctuary for persons being same or other a work in love. As a waterfall never cascading to the same sanctuary twice. Abode for our bodies, of union, of persons now step up to the altar of ancestors together who were union who were civil who were convivial behind a veil cascading. Step up, step it up, convivial. Show them, and rip the veil off the eyes of enemies of veil. See it another way. Declare the space to be an abode of bodies. See through the waterfall to those behind a veil protect the face of other, same-face same-base same substance same monstrance same sufferance same deference same-trace same-pace same-grace same-lace of marriage. A civil veil. Or it is my vow my vowels and vocables to be this same which is never that same one in gender constructed eros. Eros-faced I do do you do do in marriage. We are never the same in same sexed love. But law is civil and protects the abode of bodies. Say it: law is civil or rival is civet is perfumed is civilized is civilians is not chilling. Gone is the time of boundaries of veils or tears of borderlines of separating cascades of enigmas and hiddenness. Gone is that chilling time that does not witness the desire to be seen as witness of this union. Beyond a boundary "same" or "reciprocal" or "solidarity pacts." It is over over gone gone and done done with it that violent time. Time over, of hiding the shape of a bed, the shape of a clearing in a forest where you lie down, you might come together there, on a dark and ancient moss bed and wed and secluded spot you come to, again, coming coming together then, bed and wed. You of former hiding and sorrow and lie down and come together and making do in the secret chamber where deer bed down and you two sink there on knees in a hot devoted love where you rip the veils from the fear of prying eyes and welcome the presence of a wilder world. And say something like "as sky is my witness …" "as earth is my witness …" Come here my weeds and remove these weeds to our sameness. See our sameness. And remove the borders to our sameness, "as weeds are my witness …" Come my hands to your natural weeds and remove their fear of our sameness and see the beauty of our sameness and not sameness. Touch the body of our sameness that you know, and blameless. Clothing that waits by the side of bedding down and eyes you know in hiding. Fields of eyes not prying not hidden. It was natural and very natural to do this to be this to bed down in a clearing away from prying eyes and metabolic strangulation who said unnatural this contract a vow against perpetual wiring of denial. "As wilderness is my witness" "as wildness is my witness …" Take the vow in the wilderness. It is over, it is gone and done. It is over and done with being behind the trail of the marriage veil, behind a valance. What is the essence of this rhythm as in music which knows no boundary. Rip the boundary that is veil. Where it tunes to the body of beautiful sameness but never the same music twice. Consciousness as in music and civil it is civil and civil it is a demand to be civil. As a cascade is civil, as from the tilling of fields and this world is a cultivation of new things in civility it is a sure thing to witness *for a joining that is not easy* but is a joining work in love.

Ann Hamilton
open, 2011
Inkjet prints
Each 24 x 36 in. (61 x 91.4 cm)
Courtesy the artist

THE GUARDIAN THE S.

A
A
A
A
A
A
A
A
A
ABSOLUTE
ABSOLUTE
ABSOLUTE
ABSOLUTE
ABSOLUTE
ABSOLUTE
ACTION
ACTION
ACTION
ACTION
ACTION
ACTION
ACTION
ALL
ALL
ALL
ALL
ALL
ALL
ALL
ALL
ALL
ALL
ALL
ALL
ALL
ALL
ALL
ALL
AMERICA
AMERICA
AMERICA
AMERICA
AMERICA
AMERICA
AMERICA
AMERICA
AMERICA
AMERICAN
AMERICAN
AMERICAN
AMERICAN
AMERICAN
AMERICAN
AMERICAN
AWARE
AWARENESS
AWARENESS
BEFORE
BEFORE
BEFORE
BEFORE
BEFORE
BEFORE
BEFORE
BEFORE
BEFORE
BEFORE
BEFORE
BEFORE
BEFORE
BENEFIT
BENEFIT
BENEFITS
BENEFITS
BENEFITS
BENEFITS
BENEFITS
BODIES
BODY
BODY
BODY
BODY
BREATHE
CELEBRATE
CELEBRATES
CITIZEN
CITIZENS
CITIZENS
CITIZENS
CIVIL
CIVIL
COME
COME
COME
COME
COME
COMING
COMING
COMING
COMING
COMING
COMMITMENT
COMMITMENT
COMMITMENT
COMPANIONSHIP
CULTURE
CULTURE
CULTURE
CULTURE
CULTURE
DEDICATED
DEDICATED
DEFEND
DEFENSE
DEFENSE

MARCH 30, 2011 | VOL. 1

CRACY	OUT
CRACY	OUT
CRACY	POLITICAL
CRATIC	POLITICAL
ATION	POLITICAL
ATION	POLITICAL
ATION	POLITICAL
ATION	POLITICAL
ATION	POLITICAL
ATION	POLITICAL
ATION	POWER
ATION	POWER
ATION	POWER
JAL	POWER
JAL	POWER
JAL	POWER
ALITY	POWER
EE	POWER
EE	POWER
EE	POWER
EE	POWER
EE	POWER
EE	POWER
EE	POWER
EE	POWER
EE	POWER
EE	POWER
EE	PREJUDICE
EE	PRIDE
EE	PRIDE
EE	PRIDE
EE	PRIVATE
DOM	PRIVATE
DOM	PRIVATE
URE	PRIVATE
URE	PRIVATE
URE	PRIVATE
URE	PRIVATE
URE	PRIVATE
AY	PRIVATE
AY	PRIVATE
ING	PROTECT
ING	PROTECT
ING	PROTECT
ING	PROTECT
ING	PROTECT
ING	PROTECT
ING	PROTECT
NMENT	PROTECT
NMENT	PROTECTION
NMENT	PROTECTION
NMENT	PROTECTION
NMENT	PROTECTION
NMENT	PROTECTION
NMENT	PROTECTIONS
NMENT	PUBLIC
NMENT	PUBLIC
NMENT	PUBLIC
NMENT	PUBLIC
NMENT	PUBLIC
NMENT	PUBLIC
NMENT	PUBLIC
NMENT	PUBLIC
NMENT	PUBLIC
NESS	PUBLIC
NESS	PURSUIT
NTY	RECOGNITION
NTY	RECOGNITION
ALITY	RECOGNITION
ALITY	RECOGNITION
TANCE	RELATIONSHIP
TION	RELATIONSHIP
ACY	RESPECT
.W	RESPECT
.W	RIGHT
.W	RIGHT
.W	RIGHT
.W	RIGHT
.W	RIGHT
.W	RIGHT
.W	RIGHT
WS	RIGHT
WS	RIGHT
SAL	RIGHT
SAL	RIGHT
SAL	RIGHT
SAL	RIGHTS
SAL	RIGHTS
SAL	RIGHTS
PE	SEX
PE	SEX
PE	SEXUAL
PE	SHARED
PE	SHARED
PE	SHARED
VE	SOCIAL
VE	SOCIAL
VE	SOCIAL
VE	SOCIAL
VE	SOCIAL
AGE	SOCIETY
UAL	SOCIETY
EN	SOCIETY
EN	SPEAK
EN	SPEAKING
EN	SPEAKING
EN	SPEAKING
EN	STRAIGHT
EN	STRAIGHT
JT	STRAIGHT
JT	SUPPORT
JT	SUPPORT
JT	SUPPORT
JT	SUPPORTERS
JT	TOGETHER
JT	TOGETHER
JT	TRUTH
JT	TRUTH
JT	UNION
JT	UNION
	VOICE

speech at Toynbee Hall in east London, Warsi claimed AV represented a threat to
s to Facebook staff, drawing parallels with the role played recently by Facebook in
oice of their target. They are very obvious when deprived of their fine trappings of
anding over power to a new civilian government, the latest phase of a transition to
uber's vote. Suu Kyi, who still heads the opposition group, the National League for
he bought himself safe conduct, said Pier Luigi Bersani, the head of the opposition
ne-year-old?) This is a wild stab in the dark, but might they be going for a Jewish
Roadside bombs remain the single worst killer of U.S.... Community development,
der and executive director of the Barrio Planta Project, a community development,
center." Students to be placed in other schools after institution closes "THE city's
g Muyangren Bilingual School closed unexpectedly on Tuesday. Officials from the
ly monitor private schools since they do not fall solely under the authority of the
y troubled international school, only to be told to go home as it had closed. Now an
ent, our prime concern is finding some place where our children can continue their
g Muyangren Bilingual School. However, this is being investigated by the district
stigated by the district education watchdog. Tang Tao, an official with the district
ernment cuts of 15%, the chief executive, Alan Davey, insisted there would not be
timated that growth in power demand from data centres in the US alone would be
s Richard Eyre: director What Arts Council England has done seems quite smart.
e that has become quite uncommon: it is a pleasure and privilege to be simple and
ina has to mirror Mauritius. Rather, China should rediscover its own traditions of
ngs in Obama's plan, including a bigger commitment to renewables. But nothing's
usly raised by Ofcom chief executive Ed Richards. What no one wants to have in a
Unfriend Coal campaign calls on world's most successful social networking site to
ity will allow the waterways to be protected for public use in perpetuity, including
s yet to be decided and there are concerns that although access to towpaths will be
Us Five , review " Ronnie Scott's, London Joe Lovano has said that he doesn't play
ie Scott's, London Joe Lovano has said that he doesn't play free jazz, he plays jazz,
k to the timetable , meaning Spanish viewers can watch Villarreal v Barcelona for
President Obama pushes to find more ways for the... Pirates LaRoche, Young now
Planta Project ,a community development, education and arts school that provides
. Since the community was so good to me, I wanted to give back. I started off with
rk as an analyst for ESPN while he rehabs toward a... " Lawyer asks int'l court to
destructive device in a public place; carrying a... " L.L. Bean embraces year-round
ng a... " L.L. Bean embraces year-round free shipping "The Associated Press Could
hat Mayor Ed Lee change the name of the Tenderloin to Tempeh, a vegan, cruelty
the day when oil is depleted. By that time, he believes, we will be living in a world
ect is complete, the area will be restored to what it looked in the mid 20th century.
Kuefeng, vice president of Giant. The biggest attraction of ZT Online 2 is totally
venues. What remains of cultural enter" Easy for China "Chinese players defend a
ger and percussion-embellisher, allowing Lovano and pianist James Weidman the
eir cage on Wednesday morning at Barcelona zoo by making a three-metre leap for
parently, the zoo director was not aware that the buffalo and hippo had dashed for
will still receive 900,000 annually, which Davey called a vote of confidence in their
allow a person to be tracked by various CCTV cameras across a city. Worse, in the
to be transitional. They are democrats; they are not tribal, and they want to see a
d provide very valuable intelligence about regional militant networks and possible
ready put measures in place to ensure that nothing of this kind occurs again in the
sh when they play golf, and Li believes that is a positive contribution toward their
ng out plans for a cease-fire, exile for Gadhafi and a framework for talks on Libya's
Auditorium on Sunday tugging at the strings of The City, infamous and powerful
y and also pares down restrictions on job applicants." Malaysians flock to see first '
" Malaysians flock to see first 'gay' film "MALAYSIA'S first romantic movie with a
for both. Some gay rights advocates have called it an unfairly negative portrayal of
tegy, as the meters will be in every home. He said: Smart meters are a key part of
esults, adsThe Associated Press The Associated Press SAN FRANCISCO Google is
e was seized on January 25 along with a Pakistani associate believed to have been
raft regulation aimed to support healthy development of individual businesses and
ed by a peasant who had paid his taxes. Disappointed but proud officials talked of
t lacked rhythm and attacking, both teams touching the ball a few times and then
to 6.8 million TEUs." Better life for kids is American Dream "FOR most Americans
ain's financial crisis claims another victim: the solar power industry " The Spanish
m, for the solar industry at least, has turned sour. Just days before Christmas, the
ome countries. The utilities also complain that their coal and gas plants, which the
llowing year. This has left Spain with 10 times the amount of solar pv capacity the
ectively. There are some people who say this is not a one-off. They do not trust the
iane Coyle's Economics of Enough After mobilising thousands of protesters against
nt Barack Obama push ahead with a mandate that all citizens be required to have
clenbuterol, a banned fat-burning chemical that can be dangerous to humans. The
w it stands to profit,... " House Republicans seek IRS probe of AARP Ruling forces
yptThe Associated Press The Associated Press ADDIS ABABA, Ethiopia Ethiopia's
oreneurs, farmersThe Associated Press The Associated Press HAVANA The Cuban
hools that operate without a license, closing suddenly. The watchdog stressed that
lity check And the people who should be most anxious about this process should be
d land sales income soared five times. In this land grant procedure, the incumbent
to fewer than 8,000 units in Shanghai in February - an immediate result from the
he-third interest in the areas, settled a capital gains tax dispute with the Ugandan
ecting a slightly lowered annual national GDP figure for 2011-2015, suggesting the
r GDP "A SHANTY town of hundreds of shacks was stealthily pulverized by a local
Province, which called them a fire risk. The Xinhua news agency reported that the
uare meters, and supplying shelter and livelihood for some 2,000 people. The local
oring Festival season when many firecrackers and fireworks were set off. The local
volent demolition was unappreciated and vehemently resisted by the residents, the
y pulverizing these slum shelters at a time when resistance was weak. Is the local
sible for providing for the residents made homeless and jobless? Of course not. The
rmer Jordanian foreign minister, is returning to Libya to hold talks with Gadhafi's
ith's other major work The Theory of Moral Sentiments, he believed the pursuit of
yearning for fancier acquisitions. Thus Smith came to the obvious conclusion that
get. They are very obvious when deprived of their fine trappings of democracy and
of Moral Sentiments, he believed the pursuit of happiness to be the highest end for
ontent is subject to our Terms and Conditions | More Feeds " Daybreak suffers an
Coyle whose new book The Economics of Enough argues that current levels of debt,
nese today are several orders of magnitude richer than they were 30 years ago, but
careful planning before you die, your heirs will have to fork over a big part of their
consoling evacuees at a Tokyo center." Students to be placed in other schools after
y to run the school. Yet the sudden closure was still a shock, they said. The private
ected school investors may not have been legally authorized to run an educational

elist sermonising from his soapbox, and when he's at his best , on celebrities in the
e competition remedies there there, he said. Irrespective of my decision, competition
e sure the proper safeguards are in place. As the use of biometrics expands and our

| |
| DEMOCRACY |
| DEMOCRACY |
| DEMOCRACY |
| DEMOCRACY |
| DEMOCRACY |
| DEMOCRATIC |
| EDUCATION |
| EDUCATION |
| EDUCATION |
| EDUCATION |
| EDUCATION |
| EDUCATION |
| EDUCATION |
| EDUCATION |
| EDUCATION |
| EDUCATION |
| EQUAL |
| EQUAL |
| EQUAL |
| EQUAL |
| EQUALITY |
| FREE |
| FREE |
| FREE |
| FREE |
| FREE |
| FREE |
| FREE |
| FREE |
| FREE |
| FREE |
| FREE |
| FREE |
| FREE |
| FREE |
| FREE |
| FREE |
| FREE |
| FREE |
| FREE |
| FREE |
| FREE |
| FREE |
| FREEDOM |
| FREEDOM |
| FREEDOM |
| FUTURE |
| FUTURE |
| FUTURE |
| FUTURE |
| FUTURE |
| FUTURE |
| FUTURE |
| GAY |
| GAY |
| GAY |
| GAY |
| GIVING |
| GIVING |
| GIVING |
| GIVING |
| GIVING |
| GIVING |
| GIVING |
| GOVERNMENT |
| GOVERNMENT |
| GOVERNMENT |
| GOVERNMENT |
| GOVERNMENT |
| GOVERNMENT |
| GOVERNMENT |
| GOVERNMENT |
| GOVERNMENT |
| GOVERNMENT |
| GOVERNMENT |
| GOVERNMENT |
| GOVERNMENT |
| GOVERNMENT |
| GOVERNMENT |
| GOVERNMENT |
| GOVERNMENT |
| GOVERNMENT |
| GOVERNMENT |
| GOVERNMENT |
| GOVERNMENT |
| GOVERNMENT |
| HAPPINESS |
| HAPPINESS |
| HUMANITY |
| HUMANITY |
| IDENTITY |
| INEQUALITY |
| INEQUALITY |
| INHERITANCE |
| INSTITUTION |
| INSTITUTION |
| INSTITUTION |
| INTIMACY |
| JUSTICE |
| LAW |
| LAW |

rewarded extremists and gave the oxygen of publicity to fascists. She said
movements sweeping across the Middle East. Casey Harrell, senior campa
and humanity. That's why it is much more worthwhile to analyze the disa
The closed-door inauguration of the new government was announced after
said she hoped relations with the new government would be better. We al
Party. Berlusconi is now seeking to convince Italy's regional governors to
in which case the heat is totally off the baby and all on Justine for an i"
and arts school plans fundraiser Dyani Makous is the founder and executi
and arts school that provides free creative arts education, jobs training an
authority will arrange admittance to other schools for 40 students who we
watchdog said yesterday that it appears to be the latest example in a strir
bureau. Getting the children back in class is the top priority, Tang Tao, ar
watchdog is investigating the legal status of the private school, known as '
The school had faced financial difficulties, according to parents. They said
watchdog. Tang Tao, an official with the district education bureau, said th
bureau, said they suspected school investors may not have been legally au
pain for all. But that meant there were good organisations we have not be
to 10 new power plants by 2010. Greenpeace says this boom looks set to co
misery for all would have been deplorable, and lazy. Instead, they've appli
As Stiglitz notes, the tiny island nation of Mauritius is much poorer than
and take pride in a crusade, along with Mauritius, to create a more equal
of course. That phrase commitment to renewables means, say, tax credits
society is a situation where any one person has too much control of our me
its energy-intensive business from coal power Greenpeace says it is target
access to the towpaths. Environment minister, Richard Benyon, said: Our
canal- and river-users may be asked to pay more for leisure pursuits, or th
jazz, he plays jazz, free. On his superb new album Bird Songs, a set of adv
On his superb new album Bird Songs, a set of adventurous interpretations
on Saturday. The royal visitors and soccer news helped lighten a day in wl
agentsThe Associated Press The Associated Press PITTSBURGH Pittsbur
creative arts education, jobs training and English lessons to kids from the
Woman fatally stabbed during street argument in Potrero Hill "A 26-year-
Rwandan rebel "MIKE CORDER Associated Press THE HAGUE, Netherl
shipping "The Associated Press Could free shipping soon become a standa
shipping soon become a standard perk? L.L. Bean, the outdoors and clothi
meat substitute. It's true that the Tenderloin echoes vice and corruption a
of noise and pollution. Although there is still much controversy over the ex
shuttle buses will run between the fair site and the Chuanchang Road Sta
and fair game environment, Ji said during a conference yesterday." Plutor
kick taken by Honduras during their international friendly match in Wuh
to weave between tight and loose rhythmic zones, and the set grew more e
Zoo sources said they were stressed by the sudden introduction of African
when police had captured the animals. Time magazine compiled the list in
Other visual arts organisations saw a lifeline, especially a trio of new galle
this may be automated and done by computers. The FBI is rushing ahead
for the whole of Libya where the people have a choice over how they are go
plots. Indonesia's top police detective, Lieutenant General Ito Sumardi, sa
Ferrari also benefited, with Brazilian Felipe Massa moving up to the seven
development. The school introduced the course about two years ago, and i
Turkey, which has offered to mediate a permanent cease-fire, said the talk
crowd. Click the picture for more photos of Britney's performance. Spears
' film "MALAYSIA'S first romantic movie with a gay theme has become a s
theme has become a swift box-office success, attracting curious audiences
and transgendered people. Part of the movie's success is likely due to inte
us all more control over how we use energy at home and at work, helping w
people the option of recommending Internet search... Rising Peninsula box
him shelter. The arrest of Patek, who has a US$1 million American price
full play to their important role in economic and social development as wel
up official titles and returning home to be consoled by farmland. Rural sce
away possession too easily. Neither team did much in the first half. Argen
their children a better life or having a successful business or career is thei
has slashed its solar power subsidies Spain had one of the world's most an
slashed the level of subsidies that all new and existing photovoltaic (pv) sc
wanted them to build a decade ago after several black-outs, are losing mor
had planned for by 2010 , and a much bigger bill than it had envisioned. J
he said. This is one point on which both the renewable lobby and the powe
spending cuts in London this week, trade union leaders have been quick to
health... " Nathaniel Ford, job status saga continues "The saga that never
has launched a multiagency crackdown... " Fake friar accused of molesting
aid on US citizens "With health care reform reaching its first birthday last
says it plans to build a hydroelectric... The Associated Press The Associate
has authorized local banks to offer credit to private... The Associated Pres
departments need to jointly monitor private schools since they do not fall s
officials, rather than just Wang, a museum curator. But at this time, our c
can levy a" Is Lanka relying too much on top three? "THREE of the top fou
latest tighter policies." Bali bomb suspect nabbed in Pakistan "PAKISTAN
two weeks ago, paving the way for it to cooperate with CNOOC and Total.
is sobering up to the falsity of statistically induced impressions. But curin
in Sanya, Hainan Province, which called them a fire risk. The Xinhua new
undertook the surprise demolition coded Hammer on January 19, just befo
claimed that demolition proceeded from the best of intentions. In an expla
would be held responsible if such an accident occurred. But since this plan
decided to go it alone, taking preemptive action by pulverizing these slum
now responsible for providing for the residents made homeless and jobless
is under no obligation to compensate, as these people are outsiders whose
and opposition figures. The US is also sending diplomat Chris Stevens to
to be the highest end for humanity. Limitations A measure of material we
consists of tranquility and enjoyment. Chinese sages and philosophers we
That's why it is much more worthwhile to analyze the disaster in Japan. M
Limitations A measure of material well-being is not enough, because a per
crisis | Media Monkey " Is it just Monkey or is ITV's Daybreak looking mo
and environmental damage are unsustainable. Leave your thoughts below
caused by injustice has increased along the way, evidenced in a widening
to cover

closes "THE city's education authority will arrange admittance to other scl
paid to share some buildings and teaching facilities with a public school. C
So far, we have learned that the school is independent from the Muyangre

system, on the enthusiasm of anti-abortionists for the death penalty (that'
will mean that if News Corporation were to become too dominant in the m
enforcement moves into the future, so too should our privacy rights. - FBI

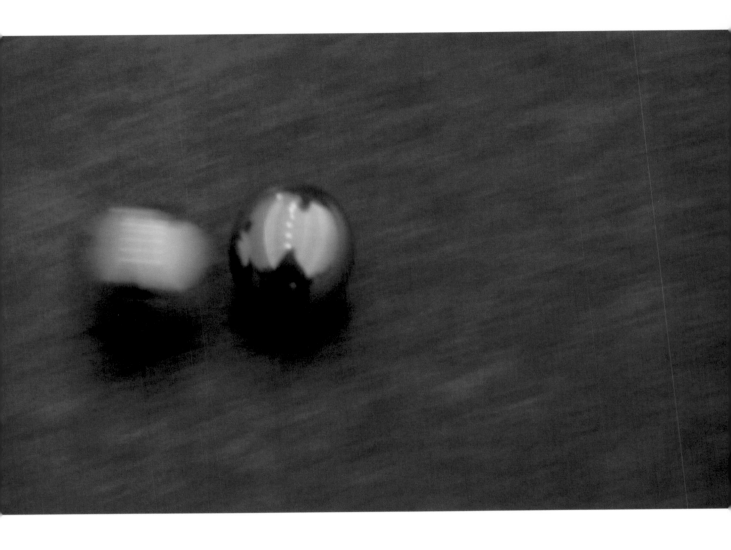

The New York Times

Missing 2 Days, Are Found Dead in Car Trunk

Shock in a lot next to the home of a missing Camden boy, Anibal Cruz, after the trunk of an unsearched car wa

Tim Larsen/Associated Press

Doug Ashford
Missing 2 Days, 2011
Inkjet print
23 ¾ x 26 in. (60.3 x 66 cm)
Courtesy the artist

Liam Gillick
From A to X, 2011
Inkjet print
24 x 20 in. (61 x 50.8 cm)
Courtesy the artist and Casey Kaplan Gallery, New York

A is for equality B is for equality C is for equality

D is for equality E is for equality F is for equality

G is for equality H is for equality I is for equality

J is for equality K is for equality L is for equality

M is for equality N is for equality O is for equality

P is for equality Q is for equality R is for equality

S is for equality T is for equality U is for equality

V is for equality W is for equality X is for equality

89

The Shards
George Albon

Today this land can't accept me
said the husband. My banishment is here, another.
Both: "I am off to the world."

Off to the world was no home.
When they said *today* it was first-person.

Throughout, there is the pulling off
from the mosaic, the world-picture in doubt
as the surface crazes.

Meant to equalize, not divide,
sex and the holding of bodies …

The hearts ask the obvious
and the opaque balk. (*Loving
v. State of Virginia*, nineteen sixty-seven,
letting races marry.)

Those are the sanctified by life,
the ones cleft by likeness, watered to go forward.
And, in obscurantist declines,
the "righteous."

This today, runners in the park
are ovaling it,
kids in brights react
to waterfowl
and I am a jurist of my physical inheritance
waiting for a word.

Falwell died with his books safe.
Romero was shot through an open door.

Edge swept out with an edge.
A helpmate brought the amphora
and was taken by its erosion.

We love the part of ourselves that is missing
we miss and love our other half
we love our other one

Holding of bodies unreckoned and volatile
Tongue laps skin but helps in speech
Love of nativity is a civil erection
Eros delays disintegration
The body's cultivation grows toward the polis
Tyrants despise the limb-and-soul gymnasium

Two standing to one both action and passion

Note well the articulations of my nature.

Law extent

but to imagine a law-god finding its way
to qualities that kept their strength
after dispersal

In that intensive morning
the words can be spoken in a different register

parting drapes to mesh with the honey-light
whole among particulates

a feeling-tone and the sensation
of its balance, its origin

The day, its touchable passage.

"I am off to the world."

Sam Durant
National Geographic Correction, Great Sioux Nation, 2011
Spray enamel on printed map
33 x 50 in. (83.8 x 127 cm)
Courtesy the artist; Blum and Poe Gallery, Los Angeles;
and Paula Cooper Gallery, New York

UNITED STATES

CANADA

ONTARIO

QUÉBEC

NEW BRUNSWICK

MAINE

MINNESOTA

WISCONSIN

MICHIGAN

VERMONT

NEW HAMPSHIRE

MASSACHUSETTS

NEW YORK

CONNECTICUT

RHODE ISLAND

IOWA

ILLINOIS

PENNSYLVANIA

MISSOURI

KENTUCKY

WEST VIRGINIA

VIRGINIA

MARYLAND

DELAWARE

TENNESSEE

NORTH CAROLINA

SOUTH CAROLINA

GEORGIA

ALABAMA

MISSISSIPPI

LOUISIANA

FLORIDA

ATLANTIC OCEAN

BAHAMAS

GULF OF MEXICO

CUBA

Tropic of Cancer

Straits of Florida

Lake Superior

Lake Michigan

Lake Huron

Lake Erie

Lake Ontario

Gulf of Maine

Map Copyright © 2008 GeoNova Publishing, Inc.
This product contains proprietary property of GeoNova Publishing, Inc., Lititz, Pennsylvania
Unauthorized use, including copying, of this product is expressly prohibited.

GeoNova

Washington, D.C. ◎ NATIONAL CAPITAL
Austin ○ STATE OR PROVINCIAL CAPITAL
New York ● MAJOR CITIES
Baltimore ●
Oakland ●
Rockford ● OTHER CITIES
Grand Island ●
Aspen ○ MAJOR URBAN AREA

LARGE PARK
SMALL PARK
MOUNTAIN PEAK
INTERSTATE HIGHWAY
U.S. HIGHWAY
STATE HIGHWAY
LIMITED ACCESS ROAD
OTHER ROAD
TIME ZONE BOUNDARY
CONTINENTAL DIVIDE

SCALE 1:4,000,000
ALBERS EQUAL AREA PROJECTION

Simon Fujiwara
Dir América, 2011
Mixed media
Dimensions variable
Courtesy the artist

29 th December, 2010
Plaza Santo Domingo
México City

Dir América,

 Ahi right whit nius from sus of da border. This year in México is ei
history moment: Da bicentenial of tha Independence and 100 year since da
Revolución. Bat what, Ai ask, is ther tu celebreit? Everry wear ai luk ai
si porberti and injustis, ai si da concuest: in da arquitectur, on da
steet, in da catolic feigt and da language dat yu imposet apon dem, Spanich..
Thelmi, du yu rili biliv dat da concuest is histori? dir América, did da
Revolución rili hapen?

 Meny people stil camnot iven rid an raigt, so in every taun square der
ar men ju sit am raigt leters in excheings for mony, wam of this men is
taiping dis leter for mi. ai am spiking in inglish an ji dos not anderstan
mi. wt good ji fill if hi anderstut?

 Dir América hir der is violens and wor, der ar drog lords and oligarca
and yu ar not free from blein. Du yu remember jau match yu tuc from Mexico?
California, Arizona, Niu México etcétera. And yu ar stil jir, on every corner
ei starucks, on every oder ei Walmart. Downte guet mi rong, ai lof yor cofee
-so crimi, sou smut. Pat ai hav ei beter aidia: wai not olso import education?
imagen da bisnes yu cut du wit da millions living ing ignorance! da Mexicans
don nid yor squini soy lates, dey nit yur help. Fink ov ol da chip leivor and
drogs dey have given yu.

 Ai wonted tu put intu words da injustis ai have sin, bat words ard sou
fiutael. México nids acción, wi ol nid acción. Last naigh ai drimt of ei new
Revolución: el Sexual Revolución. Crauds of Mexicans, wimen and men of ol
clases and etnicitis gaderd on dis square and stated ei mas orgy, at last ai
sou eigh yunaited México, it wosd beatiful, erotic. ai wonted tu partipei
(asd ai am atracted tu latino men) bat wen tei rialaisd ai wos yuropia, dei
tuc mi aguey and kilid mi. Iven im yur drims yu camt olweys guet guot yu wond.

 Tu not worry about mi, dir América, da winter is mail, aim living laikt ei
king. Tu morrow ai will bi in Yurop, soon it will bi spring.

Yurs olweys, Taip bay José Luis.
Simón Fujiwara

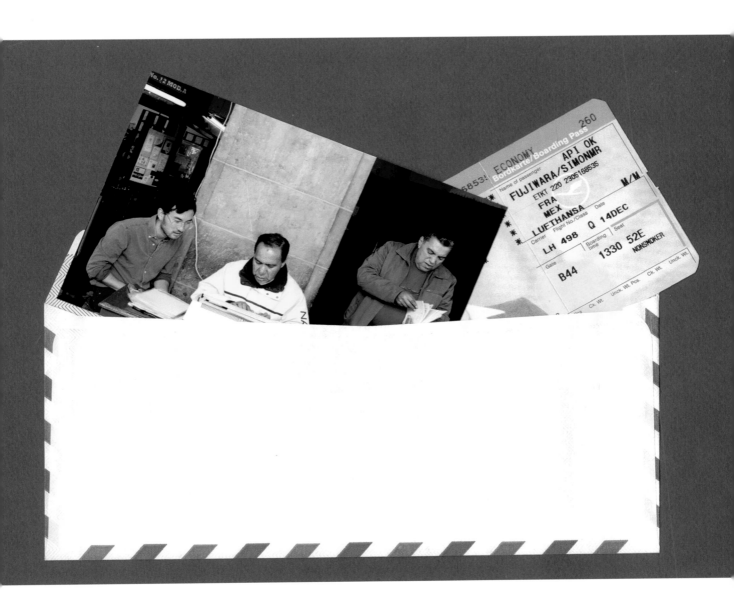

Erika Vogt
Instructions, directions, 2011
Wax, pigment, solvent, and ink on paper
11 x 8 ½ in. (27.9 x 21.6 cm)
Courtesy Overduin and Kite, Los Angeles

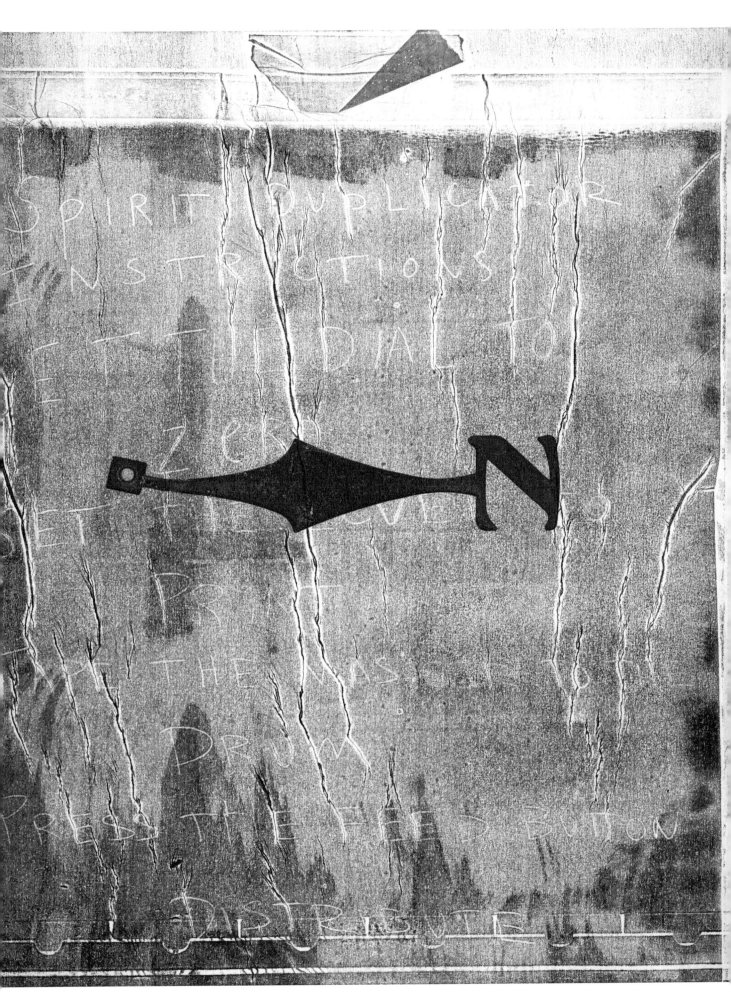

SPIRIT DUPLICATOR
INSTRUCTIONS
SET THE DIAL TO
ZERO
SET THE LEVER TO
PRINT
THE MASTER TO
DRUM
PRESS THE PLUS BUTTON
DISTRIBUTE

101

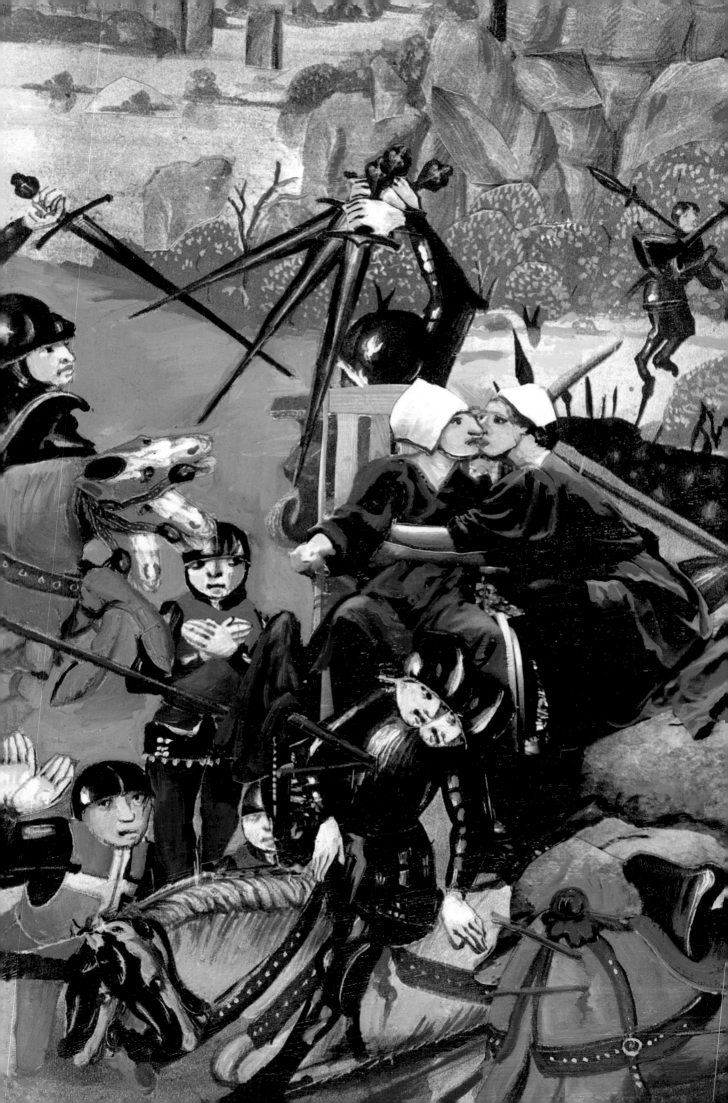

Martha Colburn
Untitled, 2011
Collage with oils on board
10 ⁵/₈ x 7 ³/₄ in. (27 x 19.7 cm)
Courtesy the artist

On Osmotic Attraction
Will Alexander

There exists scent in the realm of osmotic attraction
flowing through unscripted boundaries
which burns in the body by sensation
by absence of deprivation
by absence of scripted evil

thus
the body creates no enigma as pillage

& so moons burn
cinders explode

& regimes disassemble
& laws burn dim & turn to neon erosion

yet the body persists
as stubborn oscillation
as power according to savage insistence

& so
how can the extrinsic regulate the feral?

through law
or death
or reason?

an impossible legislation
having the power of an owl
seeking to speak by rote
the principle of Empedocles

or as someone like John Calvin
speaking in poisonous scorpion's chatter
or the earlier Savonarola
excluding prophecy as tenacious impediment

yet desire persists
over & beyond
the political summons as fate

the political being thought
as malevolent insertion
brewed & crystallized
by haunted misfortune

Amy Sillman
Fear the Beard, 2011 (details)
Inkjet prints using iPhone application software
Each 40 x 30 in. (101.6 x 76.2 cm)
Courtesy the artist and Sikkema Jenkins and Co., New York

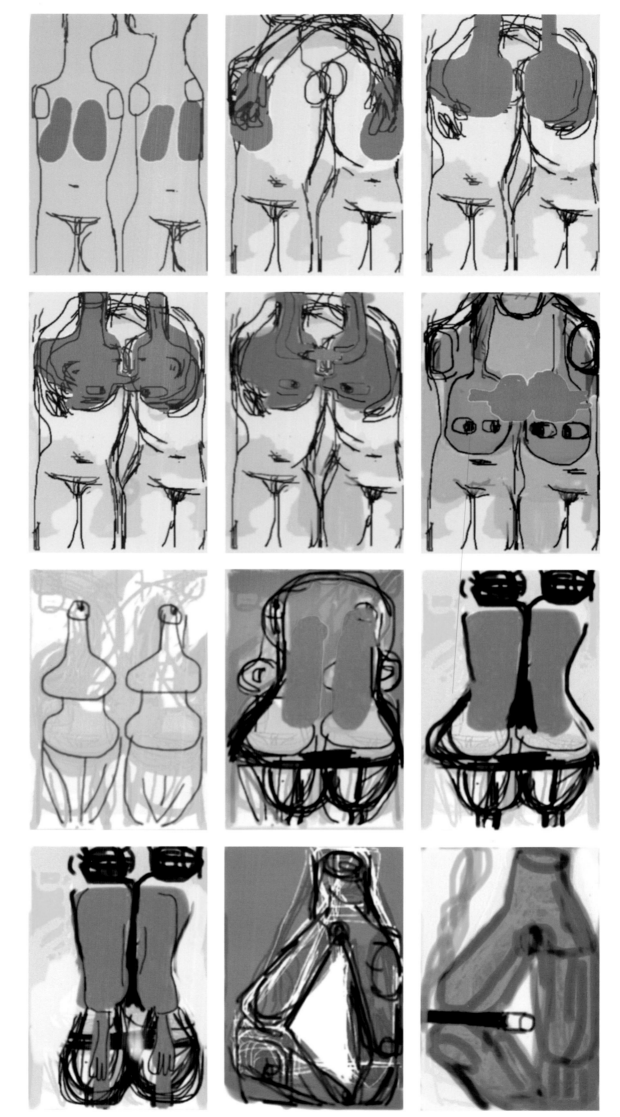

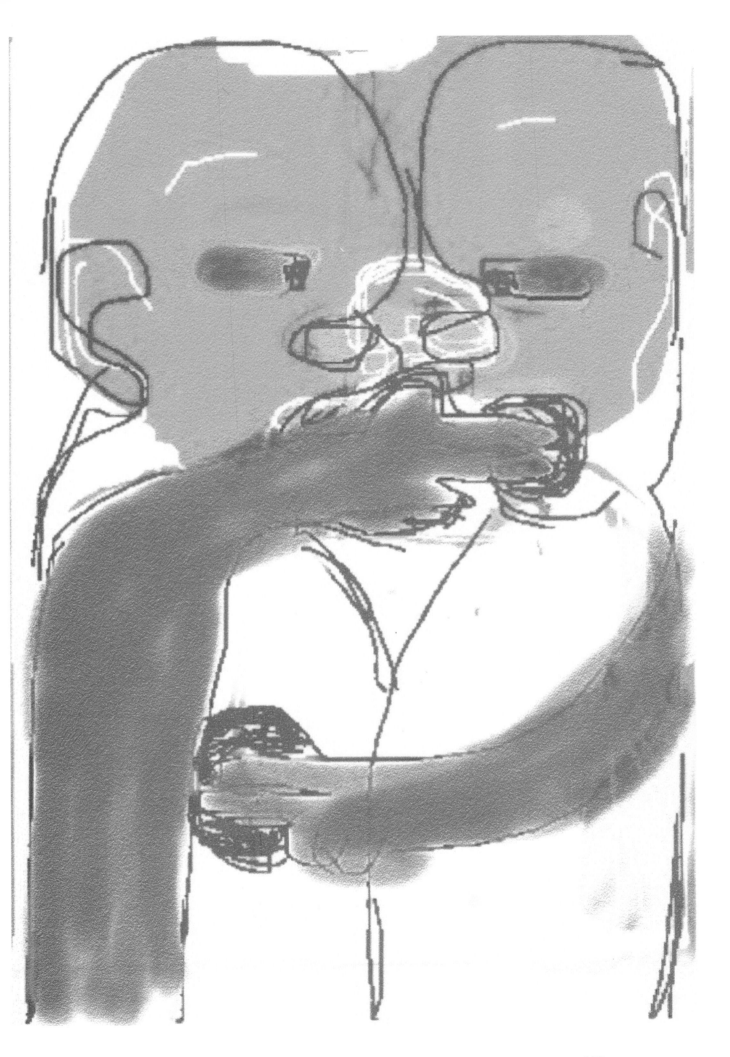

109

Lily van der Stokker
Ru Paul Annie Sprinkle, 1994
Felt-tip pen ink on paper
16 $\frac{15}{16}$ x 14 $\frac{3}{16}$ in. (43 x 36 cm)
Courtesy the artist and Leo Koenig Gallery, New York

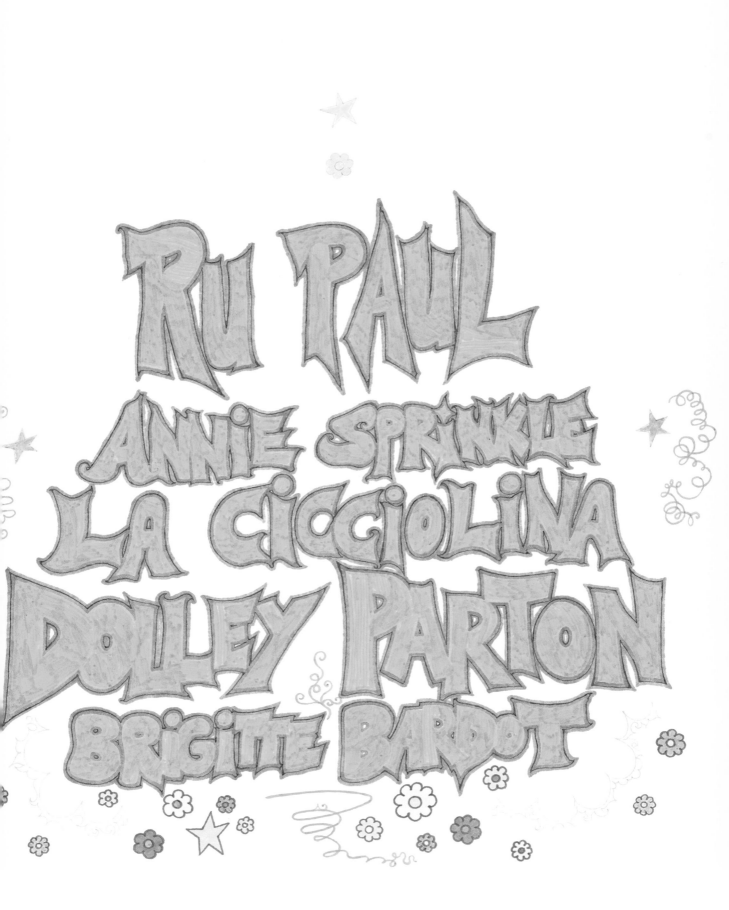

RU PAUL
ANNIE SPRINKLE
LA CICCIOLINA
DOLLEY PARTON
BRIGITTE BARDOT

Nicolás Paris
Amantes (Lovers), 2011
Graphite and colored pencil on cut and pasted paper
8 ¹/₄ x 11 ¹¹/₁₆ in. (21 x 29.7 cm)
Courtesy the artist

amantes

lovers

Allison Smith
Puzzle Ring, 2011
Collage on paper
22 ½ x 15 in. (57.2 x 38.1 cm)
Courtesy the artist and Haines Gallery, San Francisco

I Do
Ariana Reines

I DO

:

:

:

:

Why shouldn't Kevin Killian
Be able to marry the Bolivian
President Evo Morales if he wants to, and still stay married
To Dodie Bellamy too, why not? Evo
Morales has a coke-can cock we used
To say to each other after watching Democracy
Now together, an old love and I. Then I met a Bolivian
Hostile to the land policies of Evo Morales who
When I trotted out my quip about the coke-can
Cock of Evo Morales, without grandstanding that the private
 joke
When this boy and I made love was that my virility was such
That once his penis was inserted into me it was as though his
 cock
Became my cock, and moreover that my cock, my spiritual
Cock, was even thicker and longer than his physical cock, the
 one
He was fucking me with, thrumming with life like the heavy
Earth of Bolivia, with its fields of coca and maybe even quinoa
And because I am short with feet shaped like peasants'
Feet we imagined that if I had a cock it would be of the stockier
Variety, if that makes any sense? So the Bolivian I met in a bar
The Bolivian hostile to the land policies of Evo Morales, said
Really? You don't think Evo Morales has a choad? What's a
 choad I said
Sincerely ignorant. You don't know what a choad is? No
I don't I said, but I hear the word constantly. It's a cock
 thicker
Than it is wide said Patricio. Never seen one of those
In person I said. Look online said Patricio. We did it
That night in my friend's mother's bed. I'm gay
And there's not enough love in the world.
:

:

:

Suppose
There is enough love in the world.
:

:

:

It is enough, as Jesus said.
Ich habe
Genug, as Bach put it.
:
:

:

I am sitting at the table of Laurel
And Emily and Laurel is the second girl I ever
Made love to. In my life. Laurel and Emily are females in bed
Together right now and I sat at their table the other day
 thinking
About writing a poem about gay marriage and my eyes went
 blurry
Considering the benevolently empty expanse of wall opposite
 me
This happy freedom from having never given a second
Thought to the genders of Laurel and Emily or the genders of
 me
After years of agony in the dankest shitholes of human
 existence suddenly free
Not to think of it at all but only be in levity of all lead
 transubstantiated
Into bright ore of air shot through with sun I have the right to
 love and be in. Not a second
Thought until I contemplated poetry and what it would make
 me say
Of the marriage bed, for verily I wish to praise the consecration
Of love on this earth, and for all good sport in love enjoyed
 upon a pallet or up
Against a door, wheresoever it may find itself taking root in the
 culmination
Of lust or otherwise, and suddenly suck the soul so hard out of
 its seat
And shoot it into the sky in pearls of night
Physical love infusing the physical world, normal
Love that by my will should destroy the tarred chancres clotting
 the waterways and the death
And shit that are the only things the people who make money
off us will ever want for us.
:
:

:

To whom must I lend my fire and attention and for what 'be
 responsible'
And agree to let an image of liberty steal my real freedom from
 me?
I am not going to do it, spectacle of beauty that denies me. I
 am not going to do it, cock

Of the world I'm supposed to be ruled by. Why should I use
 my sanity
To reconcile every beautiful secrecy to the ugly
Ways people are willing to live? I want my own ugly
Fucking ways. I made them myself. Not to dignify giving
Up on the truth with fond things
Money can buy. Fond things on the other
Hand might be the best you ever get, be nice Ariana,
And are no small consolation, admit it, if you manage to quit
 the growing wasteland
For some sliver of storebought beatitude where at least you
 don't have to stare straight
Into the abyss all day, you can look at your computer, clean the
 cat box or whatever.

:

:

:

It is so dark to love
When you are fucking crazy in Northeast
Philly and you're a Paki fuckin Rican
Which is what Shahid told me he is, not Shaheed, Sha*hid*.
Jess looked at me and wept. I'm shy she said.
Me and Shahid comforted her and then I made her come
Screaming, other things. You have
To be alive to see how dark and hard it is to love and how
 sweet
How impossibly sweet it is to be it. In their refrigerator was a
 lot
Of ground beef. I wanted to make them so happy because of
 the dark
Climate in which they love each other and I am there too, in
 that climate
In this one, passing through. I just thought you seemed really
 free, Shahid
Said to me. Can a person say something
Just because it is true. I say one true thing and another true
 thing sticks
To it. How can I stop. Where can I stop. But I don't want to. I
love these sweet doomed
People. Doomed like me. Somebody has to say it. Doomed
 like us. You made us so happy
Jess texted me after. Your effen rad, said Shahid's first text,
 and then,
Your a beautiful soul. [*Sic*]. So is he. Saying I don't even have
 a fucking GED.
We were listening to Led Zeppelin Three. The veins straining
 up
His narrow belly. Her brown lips so melancholy.

:

:

:

Let's make a movie about a girl. A twelve-year-old
Girl. She runs a bath. She puts a thick
Stack of Seventeen magazine by the tub and squirts
Shampoo into the water. Foam.
She goes to the kitchen, opens the refrigerator, removing
Cold cuts, and, a thick clot of roast beef and smoked turkey
In one hand, returns to the bathroom to disrobe. Eating beef
In hot water she begins to read.
:

:

:

 What
Has she
To do with marriage
This little girl who like this
Little piggy had roast beef?
 Imagine this film
That does not exist.
:

:

:

This little girl, my friend,
Needs a culture that consecrates love.
:

:

:

Scrofulous sapling
On which begrimed pigeons full of transfats and carbon
 monoxide do their jug jug
:

:

:

The public place of love.
The secret night. It's not like Kevin Killian
Ever said anything to me about Evo Morales but I have a thing
 for Evo Morales
And whenever I love somebody I always immediately assume
 someone else wonderful
Should love that person, would be better than me for her or
 him anyway.
Evo Morales, the president of Bolivia, is a bachelor. The first
 lady of Bolivia
Is the sister of Evo Morales. Could he be gay? He could be
 asexual and that
Would also be a-ok. The family love consecrated by the First

Lady position of his sister
Seems also a beautiful thing to me. One need not marry
Sexually nor fuck or ever say cock or pussy or anything yucky
 like military
Industrial complex to be a being whose love should be offered
 consecration
And witness of state and public because for there to be a polis
Love must be accorded the blessings and formalities of ritual
And place. People probably do make mean jokes about Evo
Morales. Not just nice jokes like mine about his and my coke-
 can cock.
Sexuality and its supposed lacks and its supposed misdirections
 are ways
To hurt people in a culture for which love has no
Value. Ores of love, furnaces and churning bodies of love, the
 cozy possibility of going on
Day after day parceling out divinity between the marriage bed
And the kitchen with the pot of red
Quinoa I emptied into my mouth for the sake of this poem
:

:

:

Marry me is something I say to the sky
And to caves, Marry me is something I have always had
 to say a hundred
Times a day to the person I am loving at the time and the
 person always also demanding
Marriage from me a hundred times a day, Marry Me a thing to
 say before you kiss
And Marry Me A Little is a song
Or a play I forget which by the gay genius Stephen Sondheim.
Marry Me is a thing to say
Enaureoled in physical love, gorging yourself on a burrito the
 size of your whole head
When you're too spent and too drunk with joy to do anything
 but eat
And gaze at each other, no matter how bad the shit still is
Out there. Marry me.
Of continuity no monopolist, a poor steward of bills and at
 best
A dithering shepherd is what I can say for myself, though
 flocked here

And there with love I do get
From Point A to Point B. Portending
Grace for the owners of all the beds
I make love in, portending, yes, marriages of bliss and legal
Sanctity, if not sanction. Staying Alive
Is such a great song, I sometimes remember
To think. Marrying is a thing to do
For love that the state should bless
With rights. The lady who loves the Eiffel
Tower married it. In Haiti I was told it's Jupiter
And Mercury I'll marry, in addition to persons.
What is the nearness of you not being
Here in the dark. It is the chill
Of a whole people jizzing on Personal
Computers.
 At times I'd thought the death
I felt in every second was the little
Death that breaks every line
In poetry. That I'd end
My deaths in marriage and prose, burbling
And tranquilly variegated, marrying seconds to minutes
And days to years, spilling in creamed cascades
Over the brinks and never to break again, some
Parson in myself stretching disgust and revolt taut over a longer
 length
Of my own life than I've ever imagined possible, forcing me,
only
 mildly censoriously,
To take it a little at a time for a long long way, such a marriage
 of wet pupae
In the moral absence of a world, plowing stars
With the ointments of love, day after day in this
Only America of Earth, could it ever happen and will I ever live
 to see that day
We stop delivering our love in the form of money transacted
 for show
Of splendor via Ticketmaster or product to dignify isolation as
 project
And the pleasure of rights makes us all gay for each other, so so
Gay for each other, forever and ever Amen?

Laylah Ali
Untitled, 2011
Gouache and ink on paper
4 ⅞ x 3 ⅜ in. (12.4 x 8.6 cm)
Courtesy the artist

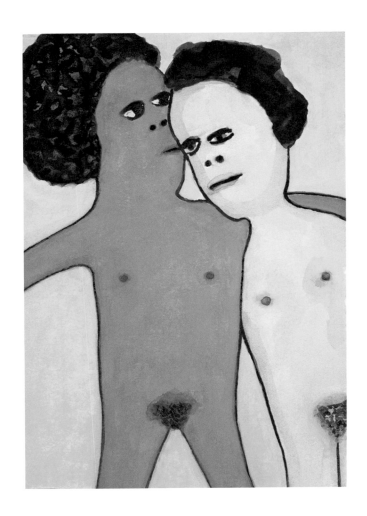

126

Christian Holstad
Learning to Share a Sink, 2011
Staples and collage on burned paper
17 ½ x 23 in. (44.5 x 58.4 cm)
Courtesy the artist and Victoria Miro Gallery, London

Carlos Motta
The Transformation of Equality, 2011
Inkjet print
34 x 22 in. (86.4 x 55.9 cm)
Courtesy the artist

WE, WHO FEEL DIFFERENTLY,

♥

BUILD AN AGENDA
BASED ON THE NEEDS OF
QUEER MINORITIES
REJECT THE POLITICS OF
ASSIMILATION, STOP BEGGING
FOR TOLERANCE
WELCOME THE CELEBRATION OF
SEXUAL AND GENDER DIVERSITY
DEMAND
THE TRANSFORMATION OF
THE SYSTEM
TRULY DESACRALIZE
DEMOCRACY AND DEMORALIZE
THE JUDICIARY
DEFINE OUR
EMOTIONAL AND SEXUAL
NEEDS ON OUR OWN TERMS
VALUE CRITICAL DIFFERENCE
INSTEAD OF FALSE EQUALITY

from *Bharat jiva*
kari edwards

the day shifts, we talk to each other the way we talk to each other, the luster fades, our bodies fill with sap, there is a shift, joy reappears before another personal narrative burns to a heap of citations, continuing in complicated machinery, becoming blood knots in space, both the living and dead surround the present has been. I open my eyes in the full force of fear and hesitation, frozen in passing passageways with endless permutations, subjected to violence, stupidity, and love.

searching for an endless solution, wanting to denounce tomorrow's demise, something to fill the day's impression, haunted by coarse salt-crusted answers, lost singing nothing new, passing through expecting many days ago and many times since. together we watch for snakes and other pests, weather apathy, exchange cautious platitudes amid stick pronouns, search empty ocean remnants in an empty ocean. something kills a passing hope, falls from a building, burns in communal violence, because the morning is "x," caught in "x," resembles plan "x," an incident irritation chained to endless solutions.

can I do this spiritual drag, collective agony wishful thinking, fearful peek-a-boo actuality about to be read in unapologetic disinterested participation against fantasy without benefit familiarity, remembering distortion, forgetting drudgery necessary to consume anything cement sorrow, surrounded by transfer credit surcharge immortal siege ideology, submissive to appliance bodyisms in doubt in the face of stupidity—oops— knowledge, derivative of skin, bone, eyes and the rest, opposite abrupt aggressive remoteness here to serve another ascendant say-so. I tremble in doubt, divided by multiple entry points and explosive content wrapped in rambling overlays sent to the council on commentary, and without exception the animation either frenetic or dull, shifts to no options left, recognizing useless hope in the face of bomb holes caused by numbering digits.

the dream points to glass things, gone and forgotten impossible syllables transplanted nothing empty still in session, pumping blood from disembodied, shrieking, beheaded planted on a pedestal _____ ... unless contempt rushes in to waste the metaphors, but I am alive in the indescribable, uneditable, ceaseless simply repeated for better national reincarnation about to happen, going on about marriage and love, seeing through someone's saint eternity, repeating words, building walls, claiming door. this is the land default far from simply erased, being decapitated, leaving letters out, changing thus to "dis," under psychosis. this is proximity land by length and number, where one can maintain death of the self due to lack of a self, referring to another self lost in upstaged tribal purging, pressed fluid and application of details to every detail in heaps of refuse, chanting air hole vastness, forgetting little lungs breathing.

I have to start this again too many times on someone else's planet asking why another noncommunicative withdraw, shadow show, fissures in space, queer in a box brought to tears, knowing how lovely a flower pot on a deck removed for refurbishing can be, stills something sea. maybe again, maybe everyone knows the next move before it happens, otherwise another clay day, starting one forgetting another, twisting unnatural shape for maximum pleasure with no purpose. next week's aromatic extremity mutates to scantly a color beyond black, I speak to a mother about twenty years ago, now and again, twenty years ago, how they die, how they load a gun, how we belong to a warning in the time of security, gray tone with no theme, only moral categorical crimes made up as they happen. trying to fix my attention on what is so rigid to distort the ever changing changeless access apparition of myself drifting in soundless weight, measured by nets, writing fire, erasing the without end.

Nicole Eisenman
Celeste and Ulrika, 2010
Ink, enamel, and gesso on paper
25 ½ x 19 ½ in. (64.8 x 49.5 cm)
Courtesy the artist; Leo Koenig Gallery, New York;
and Susanne Vielmetter Projects, Los Angeles

Robert Gober
Untitled, 2010
Ink on Post-it with accompanying text
3 ½ x 3 ½ in. (8.9 x 8.9 cm)
Courtesy the artist and Matthew Marks Gallery, New York

It's like that
old Haiku

First they came for
the gays
But I didn't know
I was gay
So who gives a shit

I wrote this note late at night as a reminder to tell it to my partner who was away at the time. I heard it on *The Daily Show* with Jon Stewart. The segment was about Ken Mehlman, who was the chairman of the Republican National Committee and campaign manager for President George W. Bush during the time when the Republican Party was working hard to exploit gay prejudice. The Federal Marriage Amendment had been proposed, which would have altered the constitution to ban same-sex marriage. Mehlman worked hard to advocate for this change to our constitution. He just recently came out as gay and is now advocating for same-sex marriage, working with the American Foundation for Equal Rights.

Andrea Bowers and Catherine Opie
Untitled, 2009
Chromogenic print
12 x 9 in. (30.5 x 22.9 cm)
Courtesy the artists

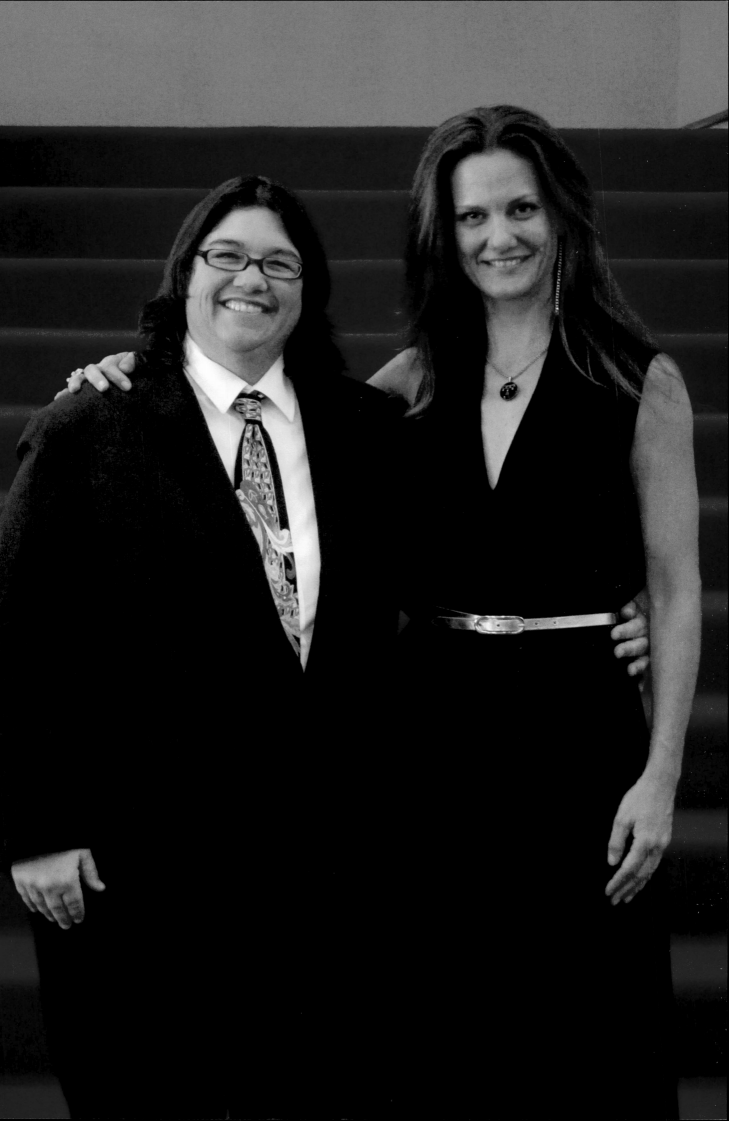

Angels in America
Frank Rich

———

To appreciate how much and how unexpect-edly our country can change, look no further than the life and times of Judith Dunnington Peabody, who died on July 25* at eighty in her apartment on Fifth Avenue in New York.

The proper names in her biographical sketch suggest a stereotype from a bygone *New Yorker* cartoon: Miss Hewitt's Classes, the Ethel Walker School, Bryn Mawr, the Junior League. She "was introduced to society," as they said of debutantes back then, at the Piping Rock Club, Locust Valley, N.Y., in 1947. As the fashionable wife of Samuel P. Peabody in the decades to follow, she shared the society pages with Pat Buckley, Babe Paley, and Jacqueline Kennedy Onassis. But to quote Tracy Lord,

the socialite played by Katharine Hepburn in the classic high-society movie comedy *The Philadelphia Story*, "The time to make up your mind about people is never." In 1985, Judith Peabody, a frequent contributor to the tradi-tional good causes favored by those of her class, did the unthinkable by volunteering to work as a hands-on caregiver to AIDS patients and their loved ones.

Those patients were then mostly gay men, and, as Guy Trebay recently wrote in the *New York Times*, they were "treated not with compassion but as bearers of plague." There was no drug regimen to combat AIDS, and there were many panicky rumors about how its death sentence could be spread through ca-sual contact. People of all types and political persuasions shunned dying gay men even as they treated healthy gay men and lesbians as, at best, second-class citizens. The *Times* did not put the mysterious disease on Page 1 until after the casualty rate exceeded 500 and didn't start covering it in earnest until Rock Hudson died

*

* "Angels in America" first appeared in the *New York Times*, August 14, 2010.—ed.

of AIDS three years after that. In 1985, the term "gay" itself was an untouchable for writers in this newspaper.

Thanks to Peabody's prominence, her example had a discernible effect in beating back ignorance and fear in New York. But twenty-five years ago, few could have imagined a larger narrative that might lead to full civil rights for gay Americans. That was change almost no one believed in. Nor could many have imagined that a day would come, as it did ten days after Peabody's death, when a federal judge in San Francisco would rule it unconstitutional for same-sex couples to be denied the right to be lawfully wedded in sickness and in health. Yet here America is, in 2010, on the brink of seeing that issue reach the Supreme Court.

I didn't know Peabody, but I can only imagine that her determination to make a difference was in some part influenced by her mother-in-law, Mary Peabody. The wife of an Episcopal bishop and the mother of a governor of Massachusetts, Mary Peabody spent two nights in jail, at the age of seventy-two, after participating in sit-ins to protest racial segregation in St. Augustine, Fla., in 1964. Many were baffled why a patrician grandmother of seven would travel thousands of miles to volunteer for a racial confrontation with police officers who were armed with tear gas, dogs, and electric cattle prods. "I shall go wherever I am asked to participate for freedom," she said.

The Peabody women were among the countless players in these larger civil rights dramas. They are testimony to the courage, big-heartedness, and sense of fundamental fairness that can flower in our country in the most unexpected quarters even as the angrier and more malign voices dominate the debate. And sometimes over the long term—an obscenely long term in the case of black civil rights—the good guys and women can win real victories. Make no mistake about it: The Proposition 8 trial, Judge Vaughn Walker's decision, and the subsequent reaction to it (as much a non-reaction

as anything else) constitute a high point in America's history-long struggle to live up to its democratic ideals.

Much has been said about the triumph of the odd-couple legal team, the former *Bush v. Gore* adversaries Ted Olson and David Boies, who opposed Prop 8 in court. But of equal significance is the high-powered lawyer on the other side, Charles Cooper. He was named one of the ten best civil litigators in Washington in the same *National Law Journal* list that included Olson and, in his pre–Supreme Court incarnation, John Roberts. Yet, as Judge Walker made clear in his 136-page judgment, Cooper, for all his talent and efforts, couldn't find facts to support his argument that full civil marital rights for same-sex couples would harm the institution of marriage, children, or anyone else. Cooper only managed to summon two "expert" witnesses. In the judge's determination, one undermined his credibility by giving testimony contradicting his own opinions while the other provided "evidence" rendered worthless by its lack of scientific methodology or even fundamental peer-review vetting.

Boies and Olson produced nine expert witnesses with the relevant professional and academic expertise lacking in Cooper's duo and compiled an encyclopedic record of empirical findings that demolished the arguments for denying gay families equal rights under the law. In the understatement

of *The Economist*, that record "now seems a high hurdle" for the Supreme Court to overturn. That could still happen, of course, and already there are signs of a campaign from the right to besmirch the likely swing justice, Anthony Kennedy. Though Kennedy was a Ronald Reagan appointee who wrote much of the unsigned decision in *Bush v. Gore*, that did not prevent him from being called "the most dangerous man in America" by the family-values czar James Dobson after Kennedy wrote a majority opinion decriminalizing gay sex in 2003.

There has already been an attempt to discredit Walker, who has never publicly discussed his sexual orientation but has been widely reported to be gay. The notion that a judge's sexuality, gay or not, might disqualify him from ruling on marriage is as absurd as saying Clarence Thomas can't rule on cases involving African Americans. By this standard, the only qualified judge to rule on marital rights would be a eunuch. No less ridiculous has been the attempt to dismiss Walker as a liberal "activist judge." Walker was another Reagan nominee to the federal bench, recommended by his attorney general, Edwin Meese (an opponent of same-sex marriage and, now, of Walker), in a December 1987 memo residing at the Reagan library. It took nearly two years and a renomination by the first President George Bush for Walker to gain Senate approval over opposition from Teddy Kennedy, the N.A.A.C.P., La

Angels in America
Frank Rich

146

Raza, the National Organization for Women, and the many gay groups who deemed his record in private practice too conservative.

The attacks on Walker have fizzled fast. With rare exceptions from the hysterical fringe—Michele Bachmann, Newt Gingrich—most political leaders have either remained silent about the Prop 8 decision (the Republican National Committee) or punted (the Obama White House). Over at Fox News, Ted Olson silenced the states'-rights argument in favor of Prop 8 last weekend by asking Chris Wallace: "Would you like Fox's right to a free press put up to a vote and say, well, if five states have approved it, let's wait till the other forty-five states do?" (No answer was forthcoming.)

Most of those who do argue for denying marriage equality to gay couples are now careful to say that they really, really like gay people. This, like the states'-rights argument, is a replay of the battle over black civil rights. Eric Foner, the preeminent historian of Reconstruction, recalled last week via email how Strom Thurmond would argue in the early 1960s "that segregation benefited blacks and whites and had nothing to do with racism"—as if inequality were O.K. as long as segregationists pushing separate-but-equal "compromises" claimed their motives were pure.

Still another recurrent argument from the Thurmond era has it that no judge should overrule the voters, who voted 52 to 48 percent in California for Prop 8 in 2008. But as Olson also told Chris Wallace, "We do not put the Bill of Rights to a vote." It's far from certain in any event that a majority of California voters approve of Prop 8 now. A Field poll released two weeks before Walker's ruling found that Californians approved of same-sex marital rights by 51 to 42 percent. Last week a CNN survey for the first time found that a majority of Americans (52 percent) believed "gays and lesbians should have a constitutional right to get married."

None of this means that full equality for gay Americans is a done deal. Even if it were, that would be scant consolation to the latest minority groups to enter the pantheon of American scapegoats, Hispanic immigrants and Muslims. We are still a young, imperfect, unfinished country. As a young black man working as a nurse in a 1980s AIDS clinic memorably says in Tony Kushner's epic drama *Angels in America*: "The white cracker who wrote the national anthem knew what he was doing. He set the word 'free' to a note so high nobody can reach it."

But sometimes we do hit that note, however tentatively. How one wishes that the many gay Americans who were left to die in the shadows during that horrific time—and, in most cases, without a Judith Peabody, let alone a legal spouse, by their side—could hear Judge Walker's clarion call.

A Right to Marry?
Martha C. Nussbaum

The freedom to marry has long been recognized as one of the vital personal rights essential to the orderly pursuit of happiness by free men.

U.S. Supreme Court, *Loving v. Virginia* (1967)

———

1. What Is Marriage?

Marriage is both ubiquitous and central. All across our country, in every region, every social class, every race and ethnicity, every religion or nonreligion, people get married. For many if not most people, moreover, marriage is not a trivial matter. It is a key to the pursuit of happiness, something people aspire to—and keep on aspiring to, again and again, even when their experience has been far from happy. To be told, "You cannot get married" is thus to be excluded from one of the defining rituals of the American life cycle.

The keys to the kingdom of the married might have been held only by private citizens—religious bodies and their leaders, families, other parts of civil society. So it has been in many societies throughout history. In the United States, however, as in most modern nations, government currently holds those keys. Even if people have been married by their church or religious group, they are not married in the sense that really counts for social and political purposes unless they have been granted a marriage license by the state. Unlike private actors, however, the state doesn't have complete freedom to decide who may and may not marry. The state's involvement raises fundamental issues about equality of political and civic standing.

Same-sex marriage is currently one of the most divisive political issues in our nation. In November 2008, Californians passed Proposition 8, a referendum that removed the right to marry from same-sex couples who had been granted that right by the courts. This result has been seen by the same-sex community as deeply degrading. The 2009 referendum in Maine is, if anything, more shocking, since it removes a right that was granted through the legislative process. Analyzing this issue may help us understand what is happening in our country, and where we may be able to go from here.

Before we approach the issue of same-sex marriage, we must define marriage. But marriage, it soon becomes evident, is no single thing. It is plural in both content and meaning. The institution of marriage houses and supports several distinct aspects of human life: sexual relations, friendship and companionship, love, conversation, procreation and child rearing, mutual responsibility. Marriages can exist without each of these. (We have always granted marriage licenses to sterile people, people too old to have children, irresponsible people, and people incapable of love and friendship. Impotence, lack of interest in sex, and refusal to allow intercourse may count as grounds of divorce, but they don't preclude marriage.) Marriages can exist even in cases where none of these is present, though such marriages are probably unhappy. Each of these important aspects of human life, in turn, can exist outside of marriage, and they can even exist all together outside of marriage, as is evident from the fact that many unmarried couples live lives of intimacy, friendship, and mutual responsibility, and have and raise children. Nonetheless, when people ask themselves what the content of marriage is, they typically think of this cluster of things.

Nor is the meaning of marriage single. Marriage has, first, a civil rights aspect. Married people get a lot of government benefits that the unmarried usually do not get: favorable treatment in tax, inheritance, and insurance status; immigration rights; rights in adoption and custody; decisional and visitation rights in health care and burial; the spousal privilege exemption when giving testimony in court; and yet others.

Marriage has, second, an expressive aspect. When people get married, they typically make a statement of love and commitment in front of witnesses. Most people who get married view that statement as a very important part of their lives. Being able to make it, and

to make it freely (not under duress), is taken to be definitive of adult human freedom. The statement made by the marrying couple is usually seen as involving an answering statement on the part of society: we declare our love and commitment, and society, in response, recognizes and dignifies that commitment.

Marriage has, finally, a religious aspect. For many people, a marriage is not complete unless it has been solemnized by the relevant authorities in their religion, according to the rules of the religion.

Despite the fact that marriage has these three aspects, government currently plays a key role in all. It confers and administers benefits. It seems, at least, to operate as an agent of recognition or the granting of dignity. And it forms alliances with religious bodies. Clergy are always among those entitled to perform legally binding marriages. Religions may refuse to marry people who are eligible for state marriage, and they may also agree to marry people who are ineligible for state marriage. But much of the officially sanctioned marrying currently done in the United States is done on religious premises by religious personnel. What they are solemnizing (when there is a license granted by the state) is, however, not only a religious ritual, but also a public rite of passage—the entry into a privileged civic status.

To get this privileged treatment under law people do not have to show that they are good people. Convicted felons, divorced parents who fail to pay child support, people with a record of domestic violence or emotional abuse, delinquent taxpayers, drug abusers, rapists, murderers, racists, anti-Semites, other bigots, all can marry if they choose, and indeed are held to have a fundamental constitutional right to do so[1]—so long

*

[1] As we'll see in section 5, this has been explicitly established for prison inmates and noncustodial parents who fail to pay child support, perhaps the most extreme cases, in that states actually sought to deny marriage to these classes of people.

as they want to marry someone of the opposite sex. Although some religions urge premarital counseling and refuse to marry people who seem ill prepared for marriage, the state does not turn such people away. The most casual whim may become a marriage with no impediment but the time it takes to get a license. Nor do people even have to lead a sexual lifestyle of the type the majority prefers in order to get married. Pedophiles, sadists, masochists, sodomites, transsexuals—all can get married by the state, so long as they marry someone of the opposite sex.

Given all this, it seems odd to suggest that in marrying people the state affirmatively expresses its approval, or confers dignity. There is indeed something odd about the mixture of casualness and solemnity with which the state behaves as a marrying agent. Nonetheless, it seems to most people that the state, by giving a marriage license, expresses approval and, by withholding it, disapproval.

What is the same-sex marriage debate about? It is really not about whether same-sex relationships can involve the content of marriage: few would deny that gays and lesbians are capable of friendship, intimacy, "meet and happy conversation," and mutual responsibility, nor that they can have and raise children (whether their own from a previous marriage, children created within their relationship by surrogacy or artificial insemination, or adopted children). Certainly none would deny that gays and lesbians are capable of sexual intimacy.

Nor is the debate, at least currently, about the civil aspects of marriage: we are moving toward a consensus that same-sex couples and opposite-sex couples ought to enjoy equal civil rights. The leaders of both major political parties appeared to endorse this position during the 2008 presidential campaign, although only a handful of states have legalized civil unions with material privileges equivalent to those of marriage.

Finally, the debate is not about the religious aspects of marriage. Most of the major religions have their own internal debates, frequently heated, over the status of same-sex unions.

A Right to Marry?
Martha C. Nussbaum

Some denominations—Unitarian Universalism and Reform and Conservative Judaism—have endorsed marriage for same-sex couples. Others have taken a friendly position toward these unions. Presbyterians, Lutherans, and Methodists are divided on the issue at present, and American Roman Catholics, both lay and clergy, are divided, although the church hierarchy is strongly opposed. Still other religions (Southern Baptists, the Church of Jesus Christ of Latter-Day Saints) seem strongly opposed as a body to the recognition of such unions. There is no single religious position on these unions in America today, but the heat of those debates is, typically, internal and denominational; it is not that heat that spills over into the public realm. Under any state of the law, moreover, particular religions would be free to marry or not to marry same-sex couples.

The public debate, instead, is primarily about marriage's expressive aspects. It is here that the difference between civil unions and marriage resides, and it is this aspect that is at issue when same-sex couples reject the compromise offer of civil unions, demanding nothing less than marriage.

The expressive dimension of marriage raises several distinct questions. First, assuming that granting a marriage license expresses a type of public approval, should the state be in the business of expressing favor for, or dignifying, some unions rather than others? In other words, are there any good public reasons for the state to be in the marriage business at all, rather than the civil union business? Second, if there are such good reasons, what are the arguments for and against admitting same-sex couples to that status, and how should we think about them?

2. Marriage in History: The Myth of the Golden Age

When people talk about the institution of marriage these days, they often wax nostalgic. Until very recently, they think and often say, marriage used to be a lifelong commitment by one man and one woman, sanctified by God and the state, for the purposes of companionship and the rearing of children. People lived by those rules and were happy. Typical, if somewhat rhetorical, is this statement by Senator Robert Byrd of West Virginia during the debates over the Defense of Marriage Act:

> Mr. President, throughout the annals of human experience, in dozens of civilizations and cultures of varying value systems, humanity has discovered that the permanent relationship between men and women is a keystone to the stability, strength, and health of human society—a relationship worthy of legal recognition and judicial protection.

We used to live in that golden age of marital purity, the story goes. Now, however, things are falling apart. Divorce is ubiquitous. Children are growing up without sufficient guidance, support, and love, as adults live for selfish pleasure alone. We need to come to our senses and return to the rules that used to make us all happy.

Like most Golden Age myths, this one contains a core of truth: commitment and responsibility are under strain in our culture, and too many children are indeed growing up without enough economic or emotional support. We can't think well about how to solve this problem, however, unless we first recognize the flaws in this mythic depiction of our own past. Like all fantasies of purity, this one masks a reality that is far more varied and complex.

To begin with, Senator Byrd's idea that lifelong monogamous marriage has been the norm throughout human history is just mistaken. Many societies have embraced various forms of polygamy, informal or common-law marriage, and sequential monogamy. People who based their ethical norms on the Bible too rarely take note of the fact that the society depicted in the Old Testament is polygamous.

In many other ancient societies (and some modern ones) sex outside marriage was or is a routine matter: in ancient Greece, for example, married men routinely had socially approved

sexual relationships with prostitutes (male and female), and, with numerous restrictions, younger male citizens. One reason for this custom was that women were secluded and uneducated, thus not able to share a male's political and intellectual aspirations. If we turn to Republican Rome, a society more like our own in basing marriage on an ideal of love and companionship,[2] we find that this very ideal gave rise to widespread divorce, as both women and men sought a partner with whom they could be happy and share a common life. We hardly find a major Roman figure, male or female, who did not marry at least twice. These Romans are often admired (and rightly so, I think) as good citizens, people who believed in civic virtue and tried hard to run a government based on that commitment. Certainly for the founders of the United States the Roman Republic was a key source of both political norms and personal heroes. And yet these heroes did not live in a marital Eden. Reading what has come down to us reminds us that human beings always have a hard time sustaining love and even friendship, and that bad temper, incompatibility, and divergent desires are no invention of the sexual revolution.[3] Certainly they are not caused by the recognition of same-sex marriage. We've always lived in a postlapsarian world.

The rise of divorce in the modern era, moreover, was spurred not by a hatred of marriage, but, far more, by a high conception of what marriage ought to be. It's not just that people began to think that women had a right to divorce on grounds of bodily cruelty, and that divorce of that sort was a good thing. It's also that Christians began insisting—just like those ancient Romans—that marriage was about much more than procreation and sexual relations. John Milton's famous defense of divorce on grounds of incompatibility emphasizes "meet and happy conversation" as the central goal of marriage, and notes that marriage ought to fulfill not simply bodily drives, but also the "intellectual and innocent desire" that leads people to want to talk a lot to each other. People are entitled to demand this from their marriages, he argues, and entitled to divorce if they do not find it. If we adopt Milton's attractive view, we should not see divorce as expressing (necessarily) a falling away from high moral ideals, but rather as expressing an unwillingness to put up with a relationship that does not fulfill, or at least seriously pursue, high ideals.

In our own nation, as historians of marriage emphasize, a social norm of monogamous marriage was salient, from colonial times onward.[4] The norm, however, like most norms in all times and places, was not the same as the reality. Studying the reality of marital discord and separation is very difficult, because many if not most broken marriages were not formally terminated by divorce. Given that until rather recently divorce was hard to obtain, and given that America offered so much space for relocation and the reinvention of self, many individuals, both male and female, simply moved away and started life somewhere else. A man who showed up with a "wife" in tow was not

*

[2] See Susan Treggiari, *Roman Marriage* (Oxford: Oxford University Press, 1991). Her study of grave inscriptions (inter alia) gives rich evidence of what people sought in marriage and thought good to say about their marriages.

[3] In fact, there is no better antidote to the myth of marital purity than to read Cicero's account of the unhappy marriage of his brother Quintus to Pomponia Attica, the sister of his best friend Atticus. See Cicero, *Letters to Atticus*, vol. 1, ed. and trans. D. R. Shackleton Bailey (Cambridge, MA: Loeb Classical Library, 1999), no. 94, May 5 or 6, 51 B.C.E.

*

[4] In this section, I draw primarily on Nancy F. Cott, *Public Vows: A History of Marriage and the Nation* (Cambridge, MA: Harvard University Press, 2000), and Hendrik Hartog, *Man and Wife in America: A History* (Cambridge, MA: Harvard University Press, 2000).

A Right to Marry?
Martha C. Nussbaum

likely to encounter a background check to find out whether he had ever been legally divorced from a former spouse; such background checks across state lines would have been virtually impossible. A woman who showed up calling herself "the Widow Jones" would not be asked to show her husband's death certificate before she could form a new relationship and marry. The cases of separation that do end up in court are the tip of a vast uncharted iceberg. If, as historian Hendrik Hartog concludes about the nineteenth century, "marital mobility marked American legal and constitutional life,"[5] it marked, far more, the daily lives of Americans who did not litigate their separations.

Insofar as monogamy was reality, we should never forget that it rested on the disenfranchisement of women. Indeed, the rise of divorce in recent years is probably connected to women's social and political empowerment, more than to any other single factor. When women had no rights, no marketable skills, and hence no exit options, they often had to put up with bad marriages, with adultery, neglect, even with domestic violence. When women are able to leave, they demand a better deal. This simple economic explanation for the rise of divorce—combined with Milton's emphasis on people's need for emotional attunement and conversation—is much more powerful than the idea of a fall from ethical purity in explaining how we've moved from where we were to where we are today. But if such factors are salient, denial of marriage to same-sex couples is hardly the way to address them.

Throughout the nineteenth and early twentieth centuries, a distinctive feature of American marriage has been the strategic use of federalism. Marriage laws have always been state laws (despite recurrent attempts to legislate a national law of marriage and divorce[6]).

But U.S. states have typically used that power to compete with one another, and marriage quickly became a scene of competition. Long before Nevada became famous as a divorce haven, with its short residency requirement, other states assumed that role. For quite a stretch of time, Indiana (surprisingly) was the divorce haven for couples fleeing the strict requirements of states such as New York (one of the strictest until extremely recently) and Wisconsin. The reasons why a state liberalized its laws were complex, but at least some of them were economic: while couples lived out the residency requirement, they would spend money in the state.[7] In short, marriage laws "became public packages of goods and services that competed against the public goods of other jurisdictions for the loyalty and the tax dollars of a mobile citizenry."[8]

What we're seeing today,* as seven states (Massachusetts, Connecticut, Iowa, Maine, New Hampshire, Vermont, and, briefly, California) have legalized same-sex marriage, as others (California, Vermont, until September 2009, and Connecticut before the recent court decision) have offered civil unions with marriage-like benefits, and yet others (New York) have announced that, although they will not perform same-sex marriages themselves, they will recognize those legally contracted in other jurisdictions, is the same sort of competitive process—with, however, one important difference. The federal Defense of Marriage Act has made it clear that states need not give legal recognition to marriages legally contracted elsewhere. That was not the case with competing divorce regimes: once legally divorced in some

*

[7] Ibid., 14.

[8] Ibid.

* "A Right to Marry?" first appeared in the book *From Disgust to Humanity: Sexual Orientation and Constitutional Law* in 2010. For the states in which same-sex marriage is legal as of this writing, see Apsara DiQuinzio, page 13.—ed.

*

[5] Hartog, 19.

[6] See Hartog, 18–19.

other U.S. state, the parties were considered divorced in their own state as well.

Although the situation of nonrecognition faced by same-sex couples does not parallel the history of our varying divorce regimes, it does have a major historical precedent. States that had laws against miscegenation refused to recognize marriages between blacks and whites legally contracted elsewhere, and even criminalized those marriages. The Supreme Court case that brought about the overturning of the antimiscegenation laws, *Loving v. Virginia*, was such a case. Mildred Jeter (African American) and Richard Loving (white) got married in Washington, D.C., in 1958. Their marriage was not recognized as legal in their home state of Virginia. When they returned there they were arrested in the middle of the night in their own bedroom.[9] Their marriage certificate was hanging on the wall over their bed. The state prosecuted them, since interracial marriage was a felony in Virginia, and they were convicted. The judge then told them either to leave the state for twenty-five years or to spend one year in jail. They left, but began the litigation that led to the landmark 1967 decision.

Looking back at her case on its fortieth anniversary in 2007, Mildred Jeter issued a rare public statement, saying that she saw the struggle she and Richard waged as similar to the struggle of same-sex couples today:

> My generation was bitterly divided over something that should have been so clear and right. The majority believed ... that it was God's plan to keep people apart, and that government should discriminate against people in love. But ... [t]he older generation's fears and prejudices have

given way, and today's young people realize that if someone loves someone they have a right to marry. Surrounded as I am now by wonderful children and grandchildren, not a day goes by that I don't think of Richard and our love, our right to marry, and how much it meant to me to have that freedom to marry the person precious to me, even if others thought he was the "wrong kind of person" for me to marry. I believe all Americans, no matter their race, no matter their sex, no matter their sexual orientation, should have that same freedom to marry.[10]

The politics of humanity may seem to require us to agree with her. Let us, however, consider the arguments on the other side.

3. The Panic over Same-Sex Marriage: Arguments, Contamination Fears

As we examine the arguments against same-sex marriage, we must keep two questions firmly in mind. First, does each argument really justify legal restriction of same-sex marriage, or only some people's attitudes of moral and religious disapproval? We live in a country in which people have a wide range of different religious beliefs, and we agree in respecting the space within which people pursue those beliefs. We do not, however, agree that these beliefs, by themselves, are sufficient grounds for legal regulation. Typically, we understand that some arguments (including some but not all moral arguments) are public arguments bearing on the lives of all citizens in a decent society, and others are intrareligious arguments. Thus, observant Jews abhor the eating of pork, but few if

*

*

[9] See "Mildred Loving of Loving v. Virginia Speaks Out about Marriage Equality," http://lesbianlife.about.com. [10] Ibid.

A Right to Marry?
Martha C. Nussbaum

any would think that this religiously grounded abhorrence is a reason to make the eating of pork illegal. The prohibition rests on religious texts that not all citizens embrace, and it cannot be translated into a public argument that people of all religions can accept. Similarly in this case, we must ask whether the arguments against same-sex marriage are expressed in a neutral and sharable language, or only in a sectarian doctrinal language. If the arguments are moral rather than doctrinal, they fare better, but we still have to ask whether they are compatible with core values of a society dedicated to giving all citizens the equal protection of the law. Many legal aspects of our history of racial and gender-based discrimination were defended by secular moral arguments, but that did not insulate them from constitutional scrutiny.

Second, we must ask whether each argument justifies its conclusion, or whether there is reason to see the argument as a rationalization of some deeper sort of anxiety or aversion (animus, to use the language of *Romer*).

The first and most widespread objection to same-sex marriage is that it is immoral and unnatural. Similar arguments were widespread in the antimiscegenation debate, and, in both cases, these arguments are typically made in a sectarian and doctrinal way, referring to religious texts. (Antimiscegenation judges, for example, referred to the will of God in arguing that racial mixing is unnatural.) It is difficult to cast such arguments in a form that could be accepted by citizens whose religion teaches something different. They look like Jewish arguments against the eating of pork: good reasons for members of some religions not to engage in same-sex marriage, but not sufficient reasons for making them illegal in a pluralistic society.

A second objection, and perhaps the one that is most often heard from thoughtful people, insists that the main purpose of state-sanctified marriage is procreation and the rearing of children. Protecting an institution that serves these purposes is a legitimate public interest, and so there is a legitimate public interest in supporting potentially procreative marriages. Does this mean there is also a public interest in restricting marriage to only those cases where there may be procreation? This is less clear. We should all agree that the procreation, protection, and safe rearing of children are important public purposes. It is not clear, however, that we have ever thought these important purposes best served by restricting marriage to the potentially procreative. If we ever did think like this, we certainly haven't done anything about it. We have never limited marriage to the fertile, or even to those of an age to be fertile. It is very difficult, in terms of the state's interest in procreation, to explain why the marriage of two heterosexual seventy-year-olds should be permitted and the marriage of two men or two women should be forbidden—all the more since so many same-sex couples have and raise children.

As it stands, then, the procreation argument looks two-faced, approving in heterosexuals what it refuses to tolerate in same-sex couples. If the arguer should add that sterile heterosexual marriages somehow support the efforts of the procreative, we can reply that gay and lesbian couples who don't have or raise children may support, similarly, the work of procreative couples.

Sometimes this argument is put a little differently: marriage is about the protection of children, and we know that children do best in a home with one father and one mother, so there is a legitimate public interest in supporting an institution that fulfills this purpose. Put this way, the argument, again, offers a legitimate public reason to favor and support heterosexual marriage, though it is less clear why it gives a reason to restrict same-sex marriage (and marriages of those too old to have children, or not desiring children). Its main problem, however, is with the facts. Again and again, psychological studies have shown that children do best when they have love and support, and it appears that two-parent households do better at that job than single-parent households. There is no evidence, however, that opposite-sex couples do better than same-sex couples. There is a widespread feeling that

these results can't be right, that living in an immoral atmosphere must be bad for the child. But that feeling rests on the religious judgments of the first argument; when the well-being of children is assessed in a religiously neutral way, there is no difference.[11]

A third argument is that by conferring state approval on something that many people believe to be evil, same-sex marriage will force them to "bless" or approve of it, thus violating their conscience. This argument was recently made in an influential way by Charles Fried in *Modern Liberty*. Fried, who supports an end to sodomy laws and expresses considerable sympathy with same-sex couples, still thinks that marriage goes too far because of this idea of enforced approval.

What, precisely, is the argument here? Fried does not suggest that the recognition of same-sex marriage would violate the Free Exercise Clause of the First Amendment—and that would be an implausible position to take. Presumably, then, the position is that the state has a legitimate interest in banning same-sex marriage on the grounds that it offends many religious believers.

This argument contains many difficulties. First, it raises an Establishment Clause problem: for, as we've seen, religions vary greatly in their attitude to same-sex marriage, and the state, following this argument, would be siding with one group of believers against another. More generally, there are a lot of things that a modern state does that people deeply dislike, often on religious grounds. Public education teaches things that many religious parents abhor (such as evolution and the equality of women); parents often choose home schooling for that reason.

*

[11] On both of these questions, see the wide range of expert testimony summarized in Baehr v. Miike, Civ. No. 91-1394 (Hawaii Cir. Ct. Dec. 3, 1996). Even the state's own experts for the most part agreed that sexual orientation is not an important indication of parental fitness.

Public health regulations license butchers who cut up pigs for human consumption; Jews don't want to be associated with this practice. But nobody believes that Jews have a right to ask the state to impose their religiously grounded preference on all citizens. The Old Order Amish don't want their children to attend public school past age fourteen, holding that such schooling is destructive of community. The state respects that choice—for Amish children; and the state even allows Amish children to be exempt from some generally applicable laws for reasons of religion. But nobody would dream of thinking that the Amish have a right to expect the state to make public schooling past age fourteen off-limits for all children. Part of life in a pluralistic society that values the nonestablishment of religion is an attitude of live and let live. Whenever we see a nation that does allow the imposition of religiously grounded preferences on all citizens—as with some Israeli laws limiting activity on the Sabbath, and as with laws in India banning cow slaughter—we see a nation with a religious establishment, de jure or de facto. We have chosen not to take that route, and for good reasons. To the extent that we choose workdays, holidays, and so on that coincide with the preferences of a religious majority, we bend over backward to be sensitive to the difficulties this may create for minorities.

A fourth argument, again appealing to a legitimate public purpose, focuses on the difficulties that traditional marriage seems to be facing in our society. Pointing to rising divorce rates and evidence that children are being damaged by lack of parental support, people say that we need to defend traditional marriage, not to undermine it by opening the institution to those who don't have any concern for its traditional purposes. We could begin by contesting the characterization of same-sex couples. In large numbers, they do have and raise children. Marriage, for them as for other parents, provides a clear framework of entitlements and responsibilities, as well as security, legitimacy, and social standing for their children. In fact, the states that have legalized same-sex marriage, Massachusetts and Connecticut, have

among the lowest divorce rates in the nation, and the Massachusetts evidence shows that the rate has not risen as a result of the legalization.

We might also pause before granting that an increase in the divorce rate signals social degeneration. In the past, women often stayed married, enduring neglect and even abuse, because they had no marketable skills and no employment options. But let us concede, for the sake of argument, that there is a social problem. What, then, about the claim that legalizing same-sex marriage would undermine the effort to defend or protect traditional marriage? If society really wants to defend traditional marriage, as it surely is entitled to do and probably ought to do, many policies suggest themselves: family and medical leave; drug and alcohol counseling on demand; generous support, in health policies, for marital counseling and mental health treatment; stronger laws against domestic violence and better enforcement of these laws; employment counseling and financial support for those under stress during the present economic crisis; and, of course, tighter enforcement of child-support laws. Such measures have a clear relationship to the stresses and strains facing traditional marriage. The prohibition of same-sex marriage does not. If we were to study all recent cases of heterosexual divorce, we would be unlikely to find even a single case in which the parties (or an objective onlooker) felt that their divorce was caused by the availability of marriage to same-sex couples. Divorce is usually an intimate personal matter bearing on the nature of the marital relationship.

The objector at this point typically makes a further move. The very recognition of same-sex marriage on a par with traditional marriage demeans traditional marriage, makes it less valuable. What's being said, it seems, is something like this: if the Metropolitan Opera auditions started giving prizes to pop singers of the sort who sing on the television show *American Idol*, this would contaminate the opera world. Similarly, including in the Hall of Fame baseball players who got their records by cheating on the drug rules would contaminate the Hall of Fame, cheapening the real achievements of others. In general, the promiscuous recognition of low-level or non-serious contenders for an honor sullies the honor. This, I believe, is the sort of argument people are making when they assert that recognition of same-sex marriage defiles traditional marriage, when they talk about a "defense of marriage," and so forth. How should we evaluate this argument?

First of all, we may challenge it on the facts. Same-sex couples are not like B-grade singers or cheating athletes—or at least no more so than heterosexual couples. They want to get married for reasons very similar to those of heterosexuals: to express love and commitment, to gain religious sanctification for their union, to obtain a package of civil benefits—and, often, to have or raise children. Traditional marriage has its share of creeps, and there are same-sex creeps as well. But the existence of creeps among the heterosexuals has never stopped the state from marrying heterosexuals. Nor do people talk or think that way. I've never heard anyone say that the state's willingness to marry Britney Spears or O. J. Simpson demeans or sullies their own marriage. But somehow, without even knowing anything about the character or intentions of the same-sex couple next door, they think their own marriages would be sullied by public recognition of that union.

If the proposal were to restrict marriage to worthy people who have passed a character test, it would at least be consistent, though few would support such an intrusive regime. What is clear is that those who make this argument don't fret about the way in which unworthy or immoral heterosexuals could sully the institution of marriage or lower its value. Given that they don't worry about this, and given that they don't want to allow marriage for gays and lesbians who have proven their good character, it is difficult to take this argument at face value. The idea that same-sex unions will sully traditional marriage therefore cannot be understood without moving to the terrain of disgust and contamination. The only distinction between unworthy heterosexuals and the class of gays and lesbians that can possibly explain the difference in people's reaction is that the sex acts of

the former do not disgust the majority, whereas the sex acts of the latter do. The thought must be that to associate traditional marriage with the sex acts of same-sex couples is to defile or contaminate it, in much the way that eating food served by a *dalit* used to be taken by many people in India to contaminate the high-caste body. Nothing short of a primitive idea of stigma and taint can explain the widespread feeling that same-sex marriage defiles or contaminates straight marriage, while the marriages of immoral and sinful heterosexuals do not do so.

If the arguer should reply that marriage between two people of the same sex cannot result in the procreation of children, and so must be a kind of sham marriage, which insults or parodies, and thus demeans, the real sort of marriage—an argument often made[12]—we are right back to the second argument. Those who insist so strongly on procreation do not feel sullied or demeaned or tainted by the presence next door of two opposite-sex seventy-year-olds newly married, nor by the presence of opposite-sex couples who publicly announce their intention never to have children. They do not try to get lawmakers to make such marriages illegal, and they neither say nor feel that such marriages are immoral or undermine their own. So the feeling of undermining, or demeaning, cannot honestly be explained by the point about children, and must be explained instead by other darker ideas.

If we're looking for a historical parallel to the anxieties associated with same-sex marriage, we can find it in the history of views about miscegenation. At the time of *Loving v. Virginia*, in 1967, sixteen states both prohibited and punished marriages across racial lines. In Virginia, a typical example, such a marriage was a felony punishable by from one to five years in prison.

Like same-sex marriages, cross-racial unions were opposed with a variety of arguments, both political and theological. In hindsight, however, we can see that disgust was at work. Indeed, it did not hide its hand: the idea of racial purity was proudly proclaimed (e.g., in the Racial Integrity Act of 1924 in Virginia), and ideas of taint and contamination were ubiquitous. If people felt disgusted and contaminated by the thought that a black person had drunk from the same public drinking fountain, or gone swimming in the same public swimming pool, or used the same toilet, or the same plates and glasses—all widely held Southern views—we can see that the thought of sex and marriage between black and white would have carried a powerful freight of revulsion. The Supreme Court concluded that such ideas of racial stigma were the only ideas that really supported those laws, whatever else was said: "There is patently no legitimate overriding purpose independent of invidious racial discrimination which justifies this classification."[13]

We should draw the same conclusion about the prohibition of same-sex marriage: irrational ideas of stigma and contamination, the sort of "animus" the court recognized in *Romer*, is a powerful force in its support. So thought the Supreme Court of Connecticut in October 2008, saying:

> Beyond moral disapprobation, gay persons also face virulent homophobia that rests on nothing more than feelings of revulsion toward gay persons and the intimate sexual conduct with which they are associated.... Such visceral prejudice is reflected in the large number of hate crimes that are perpetrated against gay persons ... The irrational nature of the prejudice directed at gay persons, who

*

[12] For example, the *New York Times* of October 14, 2008, the day I first drafted this paragraph, carried a letter from a Roman Catholic priest to this effect.

*

[13] Loving v. Virginia, 388 U.S. 1 (1967).

A Right to Marry?
Martha C. Nussbaum

"are ridiculed, ostracized, despised, demonized and condemned" merely for being who they are … is entirely different in kind than the prejudice suffered by other groups that previously have been denied suspect or quasi-suspect class status.… This fact provides further reason to doubt that such prejudice soon can be eliminated and underscores the reality that gay persons face unique challenges to their political and social integration.[14]

We have now seen the arguments against same-sex marriage. They do not seem particularly impressive. We have not seen any that would supply government with a "compelling" state interest, and it seems likely, given *Romer*, that these arguments, motivated by animus, fail even the rational basis test.

The argument in favor of same-sex marriage is straightforward: if two people want to make a commitment of the marital sort, they should be permitted to do so, and excluding one class of citizens from the benefits and dignity of that commitment demeans them and insults their dignity.

4. What Is the "Right to Marry"?

In our constitutional tradition, there is frequent talk of a "right to marry."[15] In *Loving v. Virginia*, the case that invalidated the laws against miscegenation, the court calls marriage "one of the basic civil rights of man." A later case, *Zablocki v. Redhail*, recognizes the right to marry as a fundamental right for Fourteenth Amendment purposes, apparently under the Equal Protection Clause; the court states that "the right to marry is of fundamental importance for all individuals," and continues with the observation that "the decision to marry has been placed on the same level of importance as decisions relating to procreation, childbirth, child rearing, and family relationships."[16] Before courts can sort out the issue of same-sex marriage, they have to figure out two things: (1) what does this "right to marriage" mean? And (2) who has it?

What does the "right to marriage" mean? On a minimal understanding, it just means that if the state chooses to offer a particular package of expressive or civil benefits under the name "marriage," it must make that package available to all who seek that status without discrimination (though here "all" will require further interpretation). *Loving* concerned the exclusion of interracial couples from the institution; *Zablocki*, similarly, concerned the attempt of the state of Wisconsin to exclude from marriage parents who could not show that they had met their child support obligations. Another pertinent early case, *Skinner v. Oklahoma*, invalidated a law mandating the compulsory sterilization of the "habitual criminal," saying that such a person, being cut off from "marriage and procreation," would be "forever deprived of a basic liberty."[17] A more recent case, *Turner v. Safley*, invalidated a prohibition on marriages by prison inmates.[18] All the major cases, then, turn on the denial to a particular group of people of an institutional package already available to others.

Is the right to marry, then, merely a non-discrimination right? If so, the state is

*

[14] Kerrigan v. Commissioner of Public Health.

[15] Throughout this section I have learned a lot from the excellent examination of this question in Cass R. Sunstein, "The Right to Marry," *Cardozo Law Review* 26 (2005): 2081–120; though I differ with its analysis in several ways, it lays out the issue with incisiveness and clarity.

[16] Zablocki v. Redhail, 434 U.S. 374, 384, 384 (1978).

[17] Skinner v. Oklahoma, 316 U.S. 535 (1942).

[18] Turner v. Safley, 482 U.S. 78 (1987).

*

not required to offer marriages at all. It's only that once it does so, it must do so with an even hand. The talk of marriage as a fundamental right, together with the fact that most of these decisions mingle equal protection analysis with due process considerations, suggests, however, that something further is being said. What is it? Would it violate the Constitution if a state decided that it would offer only civil unions and drop the status of marriage, leaving that for religious and private bodies?

Put in terms of our three categories, then, does the "right to marry" obligate a state to offer a set of economic and civil benefits to married people? Does it obligate a state to confer dignity and status on certain unions by the use of the term "marriage"? And does it require the state to recognize or validate unions approved by religious bodies? Clearly, the answer to the third question is, and has always been, "no." Many marriages that are approved by religious bodies are not approved by the state, as the case of same-sex marriage has long shown us, and nobody has thought it promising to contest these denials on constitutional grounds. The right to the free exercise of religion clearly does not require the state to approve all marriages a religious body approves.

It is also pretty clear that the "right to marry" does not obligate the state to offer any particular package of civil benefits to people who marry. This has repeatedly been said in cases dealing with the marriage right.

On the other side, however, it's pretty clear that the right in question is not simply a right to be treated like others, without group-based discrimination. The right to marry is frequently classified with fundamental personal liberties protected by the Due Process Clause of the Fourteenth Amendment. In *Meyer v. Nebraska*, for example, the court says that the liberty protected by that Clause "without doubt ... denotes not merely freedom from bodily restraint but also the right of the individual to contract, to engage in any of the common occupations of life, to acquire useful knowledge, to marry, establish a home and bring up children, to worship God according to

the dictates of his own conscience, and generally to enjoy those privileges long recognized ... as essential to the orderly pursuit of happiness by free men."[19] *Loving* similarly states that "the freedom to marry, or not marry, a person of another race resides with the individual and cannot be infringed by the state," grounding this conclusion in the Due Process Clause as well as the Equal Protection Clause. *Zablocki* allows that "reasonable regulations that do not significantly interfere with decisions to enter into the marital relationship may legitimately be imposed," but concludes that the Wisconsin law goes too far, violating rights guaranteed by the Due Process Clause. With related arguments, *Turner v. Safley* determines that the restriction of prisoner marriages violates the Due Process Clause's privacy right.

What does due process liberty mean in this case? Most of the cases concern attempts by the state to forbid a class of marriages. That sort of state interference with marriage is, apparently, unconstitutional on due process as well as equal protection grounds. So, if a state forbade everyone to marry, that would presumably be unconstitutional.

Nowhere, however, has the court held that a state must offer the expressive benefits of marriage. There would appear to be no constitutional barrier to the decision of a state to get out of the expressive game altogether, going over to a regime of civil unions, or, even more extremely, to a regime of private contract for marriages, in which the state plays the same role it plays in any other contractual process.

Again, the issue turns on equality. What the cases consistently hold is that when the state does offer a status that has both civil benefits and expressive dignity, it must offer it with an even hand. This position, which I've called "minimal," is not so minimal when one

*

[19] Meyer v. Nebraska 262, U.S. 390 (1923).

looks into it. Laws against miscegenation were in force in sixteen states at the time of *Loving*.

In other words, marriage is a fundamental liberty right of individuals, and because it is that, it also involves an equality dimension: groups of people cannot be fenced out of that fundamental right without some overwhelming reason. It's like voting: there isn't a constitutional right to vote, as such—some jobs can be filled by appointment. But the minute voting is offered, it is unconstitutional to fence out a group of people from the exercise of the right. At this point, then, the question becomes: Who has this liberty/equality right to marry? And what reasons are strong enough to override it?

Who has the right? At one extreme, it seems clear that, under existing law, the state that offers marriage is not required to allow it to polygamous unions. Whatever one thinks about the moral issues involved in polygamy, our constitutional tradition has upheld a law making polygamy criminal, so it is clear, at present, that polygamous unions do not have equal recognition. (The legal arguments against polygamy, however, are extremely weak. The primary state interest that is strong enough to justify legal restriction is an interest in the equality of the sexes, which would not tell against a regime of sex-equal polygamy.)

Regulations on incestuous unions have also typically been thought to be reasonable exercises of state power, although, here again, the state interests have been defined very vaguely. The interest in preventing child abuse would justify a ban on most cases of parent-child incest, but it's unclear that there is any strong state interest that should block adult brothers and sisters from marrying. (The health risk involved is no greater than in many cases where marriage is permitted.) Nonetheless, it's clear that if a brother-sister couple challenged such a restriction today on due process/equal protection grounds, they would lose, because the state's alleged (health) interest in forbidding such unions would prevail.

How should we think of these cases? Should we think that these individuals have a right to marry as they choose, but that the state has a countervailing interest that prevails? Or should we think that they don't have the right at all, given the nature of their choices? I incline to the former view. On this view, the state has to show that the law forbidding such unions really is supported by a strong public interest.

At the other extreme, it is also clear that the liberty and equality rights involved in the right to marry do not belong only to the potentially procreative. *Turner v. Safley* concerned marriages between inmates, most serving long terms, and outsiders—marriages that could not be consummated. The case rested on the emotional support provided by marriage and its religious and spiritual significance. At one point the court mentions, as an additional factor, that the inmate may someday be released, so that the marriage might be consummated, but that is clearly not the basis of the holding. Nor does any other case suggest that the elderly or the sterile do not have the right.

The best way of summarizing the tradition seems to be this: all adults have a right to choose whom to marry. They have this right because of the emotional and personal significance of marriage, as well as its procreative potential. This right is fundamental for due process purposes, and it also has an equality dimension. No group of people may be fenced out of this right without an exceedingly strong state justification. It would seem that the best way to think about the cases of incest and polygamy is that in these cases the state can meet its burden by showing that policy considerations outweigh the individual's right, although it is not impossible to imagine that these judgments might change over time. What, then, of people who seek to marry someone of the same sex?

5. Massachusetts, Connecticut, California, Iowa: Legal Issues

This is the question with which courts are currently wrestling. Recent state court decisions had to answer four questions (using not only federal constitutional law but also the text and

tradition of their own state constitutions): First, will civil unions suffice, or is the status of marriage constitutionally compelled? Second, is this issue one of due process or equal protection, or a complex mixture of both? Third, in assessing the putative right against the countervailing claims of state interest, is sexual orientation a suspect classification for equal protection purposes? In other words, does the state forbidding such unions have to show a mere rational basis for the law, or a "compelling" state interest? Fourth, what interests might so qualify?

The four states whose Supreme Courts have recently held that there is a constitutional right to marry that covers same-sex couples—Massachusetts, California, Connecticut, and Iowa—give different answers to these questions, but there is a large measure of agreement. All agree that, as currently practiced, marriage is a status with a strong component of public dignity. Because of that unique status, it is fundamental to individual self-definition, autonomy, and the pursuit of happiness. The right to marry does not belong only to the potentially procreative. (The Massachusetts court notes, for example, that people who cannot stir from their deathbed are still permitted to marry.)

For all these expressive reasons, it seems that civil unions are a kind of second-class status, lacking the affirmation and recognition characteristic of marriage. As the California court put it, the right is not a right to a particular word, it is the right "to have their family relationship accorded dignity and respect equal to that accorded other officially recognized families." Massachusetts, California, and Connecticut draw on the miscegenation cases to make this point. The California court notes that if states opposed to miscegenation had created a separate category called "transracial union," while still denying interracial couples the status of "marriage," we would easily see that it was no solution.

Three of the four courts courts invoke both due process and equal protection. (Iowa mentions liberty briefly, but the analysis dwells on equal protection alone.) The Massachusetts court notes that the two guarantees frequently "overlap, as they do here." They all agree that the right to marry is an individual liberty right that also involves an equality component: a group of people can't be fenced out of that right without a very strong governmental justification.

How strong? Here the states diverge. The Massachusetts court held that the denial of same-sex marriages fails to pass even the rational basis test. The California, Connecticut, and Iowa courts, by contrast, held that sexual orientation is a suspect classification, analogizing sexual orientation to gender.

What state interests lie on the other side? The California, Connecticut, and Iowa opinions examine carefully the main contenders, concluding that none rises to the level of a compelling interest. Preserving tradition all

by itself cannot be such an interest: "the justification of 'tradition' does not explain the classification, it just repeats it." Nor can discrimination be justified simply on the grounds that legislators have strong convictions. None of the other proffered policy considerations (the familiar ones we have already identified) stands up as sufficiently strong.

These opinions will not convince everyone. Nor will all who like their conclusion, or even their reasoning, agree that it's good for courts to handle this issue, rather than democratic majorities. But the opinions, I believe, should convince a reasonable person that constitutional law, and therefore courts, have a legitimate role to play in this divisive area, at least sometimes, standing up for minorities who are at risk in the majoritarian political process.

6. The Future of Marriage

What ought we to hope and work for as a just future for families in our society? Should government continue to marry people at all? Should it drop the expressive dimension and simply offer civil-union packages? Should it back away from package deals entirely, in favor of a regime of disaggregated benefits and private contract? Such questions, the penumbra of any constitutional debate, require us to identify the vital rights and interests that need state protection and to think how to protect them without impermissibly infringing either equality or individual liberty. Our analysis of the constitutional issues does not dictate specific answers to these questions, but it does constrain the options we ought to consider.

The future of marriage looks, in one way, a lot like its past. People will continue to unite, form families, have children, and, sometimes, split up. What the Constitution dictates, however, is that whatever the state decides to do in this area will be done on a basis of equality. Government cannot exclude any group of citizens from the civil benefits or the expressive dignities of marriage without a compelling public interest. The full inclusion of same-sex couples is in one sense a large change, just as official recognition of interracial marriage was a large change, and just as the full inclusions of women and African Americans as voters and citizens were large changes. On the other hand, those changes are best seen as a true realization of the promise contained in our constitutional guarantees. We should view this change in the same way. The politics of humanity asks us to stop viewing same-sex marriage as a source of taint or defilement to traditional marriage, but, instead, to understand the human purposes of those who seek marriage and the similarity of what they seek to that which straight people seek. When we think this way, the issue ought to look like the miscegenation issue: as an exclusion we can no longer tolerate, in a society pursuing equal respect and justice for all.

David Wojnarowicz
Untitled (One day this kid ...), 1990
Photostat
30 ¾ x 41 in. (78.1 x 104.1 cm), ed. of 10
Courtesy The Estate of David Wojnarowicz and P.P.O.W. Gallery, New York

One day this kid will get larger. One day this kid will come to know something that causes a sensation equivalent to the separation of the earth from its axis. One day this kid will reach a point where he senses a division that isn't mathematical. One day this kid will feel something stir in his heart and throat and mouth. One day this kid will find something in his mind and body and soul that makes him hungry. One day this kid will do something that causes men who wear the uniforms of priests and rabbis, men who inhabit certain stone buildings, to call for his death. One day politicians will enact legislation against this kid. One day families will give false information to their children and each child will pass that information down generationally to their families and that information will be designed to make existence intolerable for this kid. One day this kid will begin to experience all this activity in his environment and that activi-

and information will compell him to commit sui-
e or submit to danger in hopes of being murdered
or submit to silence and invisibility. Or one
day this kid will talk. When he begins to
talk, men who develop a fear of this
kid will attempt to silence him with
strangling, fists, prison, suffocation,
rape, intimidation, drugging, ropes,
guns, laws, menace, roving gangs,
bottles, knives, religion, decapitation,
and immolation by fire. Doctors will pro-
nounce this kid curable as if his brain
were a virus. This kid will lose his consti-
tutional rights against the government's in-
vasion of his privacy. This kid will be
faced with electro-shock, drugs, and con-
ditioning therapies in laboratories
tended by psychologists and re-
search scientists. He will be
subject to loss of home, civ-
il rights, jobs, and all con-
ceivable freedoms. All this
will begin to happen in one
or two years when he dis-
covers he desires to place
his naked body on the na-
ked body of another boy.

©Wojnarowicz 1990/91

GEORGE ALBON, page 90

George Albon works fluidly across multiple forms of writing, producing spare and understated poetry in which narrative and structure are malleable components. Influenced by such diverse voices as George Oppen and William Blake, Albon blends a distilled objectivity with romantic inflections and social concerns. Speaking to the way in which Albon blurs the line between prose and poetry, Marvin Gladney has written that he "places their respective shortcomings and strengths in service to one another" through an "impressive range of narrative postures."[1]

Born in Du Quoin, Illinois, in 1954, Albon studied film theory at Southern Illinois University at Carbondale. His writing has appeared in *Crayon*, *Hambone*, *Lingo*, *non*, *Ribot*, and *Talisman*, as well as in anthologies including *Bay Poetics* and *The Gertrude Stein Awards in Innovative American Poetry*. Albon's book *Empire Life* was published in 1998 by Littoral Books, Los Angeles. *Brief Capital of Disturbances*, Omnidawn, Richmond, California, 2003, was named Book of the Year by Small Press Traffic, San Francisco. *Momentary Songs* was published in 2008 by Krupskaya, San Francisco.

WILL ALEXANDER, page 105

Also a painter and playwright, Will Alexander imbues his surrealistic poetry with a complex artistry and an interest in alchemy, reveling in the transformative potential of language. In his practice he fuses automatically generated, subconscious writing procedures with more deliberate decisions, such as using British, rather than American, spelling for certain English words, eschewing punctuation, and trafficking in metaphor. Harryette Mullen has described his sophisticated, personal lexicon as "a glossary of vertigo."[2]

Born in Los Angeles in 1948, Alexander has taught at the University of California, San Diego, and Mills College, Oakland, California, as well as at Naropa University, Boulder, Colorado, and Hofstra University, Long Island, New York. His writing has appeared in the small press publications *apex of the M*, *Callaloo*, *Conjunctions*, *Sulfur*, and *Orpheus Grid*, among others. Alexander's first book, *Vertical Rainbow Climber*, was published in 1987 by Jazz Press, Aptos, California. More recent books include *Compression &*

Purity, City Lights, San Francisco, 2011, and *The Sri Lankan Loxodrome*, New Directions, New York, 2010. He was the 2001 recipient of a Whiting Fellowship for Poetry and received a California Arts Council Fellowship in 2002.

LAYLAH ALI, page 124

Laylah Ali's meticulous gouaches and graphite drawings stem from the graphic traditions of comic books and folk art. In her works on paper, she weaves visual cues and references into loose narratives that focus only intermittently on the characters depicted or the spaces they appear to inhabit. In her signature Greenheads series, Ali rendered androgynous, synthetic figures with oversize spherical heads in a cartoonlike style. The enigmatic interactions taking place between the (not quite human) characters can be interpreted as representing different aspects of human behavior associated with racism, discrimination, and social hierarchy. The sharp or difficult subject matter in Ali's drawings is often contrasted by bright colors and technical detail, creating highly charged scenes.

Ali was born in Buffalo, New York, in 1968 and studied at Washington University in St. Louis, Missouri; the Whitney Museum Independent Study Program in New York; and the Skowhegan School of Painting and Sculpture, Madison, Maine. She lives and works in Williamstown, Massachusetts. Ali has exhibited her work at the Boulder Museum of Contemporary Art, Colorado (2008); the Walker Art Center, Minneapolis (2007); and the Museum of Modern Art, New York (2002), as well as in the 2004 Whitney Biennial and the 50th Venice Biennale (2003). Ali received the Regione Piemonte Prize from Fondazione Sandretto Re Rebaudengo, Turin, in 2001. She is represented by 303 Gallery, New York.

D-L ALVAREZ, page 69

Throughout his practice, D-L Alvarez represents symbolically charged subjects using the distancing effects of abstraction and ambiguity. He has worked in media as varied as duct tape, word forms, video, and performative installation, but his predominant medium is drawing. For one series, he uses blue pencil on paper to make images that resemble empty paint-by-numbers outlines where the numbers correspond to words instead of colors. As if reading images, Alvarez has an acute sensitivity to language, which is often manifested in overt literary references. In black-and-white, gridded

renderings, images from slasher films or the likenesses of California icons of the 1960s (Angela Davis and Charles Manson, among others) appear pixelated, distorted, and obscured. References to sex, politics, nature, and space abound in work that is conceptually rigorous and technically adroit.

Alvarez was born in Stockton, California, in 1966. He lives and works in San Francisco and Berlin. His work has been shown in galleries, museums, and film festivals including Galería Casado Santapau, Madrid (2011); the Drawing Center, New York (2011); and the University of California, Berkeley Art Museum and Pacific Film Archive (2010). He is represented by Derek Eller Gallery, New York, and Galería Casado Santapau, Madrid.

JOHN ASHBERY, page 45

At times self-reflexive or ambiguously narrative, and regularly charting topics from both popular and more specialized realms of culture, John Ashbery has, over the course of more than six decades, developed a unique and influential style of poetry. Associated with the New York School of poetry, he has also had a long career as an art critic, serving as executive editor of *Art News* from 1965 to 1972 and writing for *New York* magazine and *Newsweek*, among others. Cinema, music, and the visual arts have been powerful influences on his work, and his 1975 collection *Self-Portrait in a Convex Mirror*, whose title poem was written in response to the eponymous painting by Francesco Parmigianino, won all three major poetry prizes: the Pulitzer, the National Book Award, and the National Book Critics Circle Award.

Born in Rochester, New York, in 1927, Ashbery received his BA from Harvard and did graduate work at New York University and Columbia. His work is widely published and translated, and his many books include *Collected Poems 1956–1987*, Library of America, New York, 2008; *Planisphere*, Ecco/HarperCollins, New York, 2009; and his new translation of Rimbaud's *Illuminations*, Norton, New York, 2011. Ashbery's many honors include the Yale Younger Poets Prize, the Harvard Arts Medal, and a MacArthur "genius" grant; he was the first English-language poet to receive the Grand Prix des Biennales Internationales de Poésie. He exhibits his collages at the Tibor de Nagy Gallery in New York.

DOUG ASHFORD, page 86

Between 1982 and 1996, Doug Ashford was a member of Group Material, an art

collective that used the exhibition format as a means of promoting critical understanding in the production of contemporary culture and social awareness through its distribution and reception. In his own extended practice, Ashford creates abstract paintings, along with tempera-on-paper works that resemble nocturnes, geometric configurations, or diagrams, sometimes with historical imagery collaged onto their surfaces. Ashford's interests in the disconnect between art production and social action, and in utopic leanings and models, take material form throughout his body of work.

Ashford was born in Rabat, Morocco, in 1958 and studied at the Cooper Union, New York, where he currently teaches. Ashford's collaborative work with the collective Group Material has been exhibited at the 12th Istanbul Biennial (2011); Kunstverein München (1995); Museum of Fine Arts Boston (1994); Museum of Contemporary Art San Diego (1993); Wadsworth Atheneum, Hartford, Connecticut (1990); and the University of California, Berkeley Art Museum and Pacific Film Archive (1989), as well as in *Documenta* 8, Kassel (1987), and the Whitney Biennial, New York (1985 and 1991). Ashford's solo work has been included in the 10th Sharjah Biennial, United Arab Emirates (2011); Museo Tamayo, Mexico City (2011); and Malmö Konsthalle, Sweden (2010–11).

DODIE BELLAMY, page 58

A novelist, nonfiction author, journalist, and editor, Dodie Bellamy is a primary figure in the New Narrative movement, which transposes tools of experimental fiction and critical theory onto narrative storytelling. Her incisive and biting social critiques are often buoyed by a sense of humor and an appreciation for the absurd that cumulatively broach the real. An admirer of Kathy Acker, Bellamy blends an avant-garde leaning with an intimate autobiographical approach. Bruce Benderson has written that there is a collision of "sex and philosophy" in Bellamy's work, as she fuses "trash with high culture, injecting theory with the pathos of biography and accomplishing nothing less than a fresh and sustained lyricism."[4]

Bellamy hails from the Calumet region of Indiana and studied at Indiana University. Publications include *the buddhist*, Publication Studio, Portland, 2011; the chapbook *Whistle While You Dixie*, Summer BF Press, San Francisco, 2010; *Barf Manifesto*, Ugly Duckling Presse, Brooklyn, New York, 2008; *Pink Steam*, Suspect Thoughts Press, San Francisco, 2004; *Academonia*, Krupskaya, San Francisco, 2006; *The Letters of Mina Harker*, Hard Press Editions, Lenox, Massachusetts, 1998, reprinted by University of Wisconsin Press, 2004; *Broken English*, Meow Press, Buffalo, New York, 1996; and *Feminine Hijinx*, Hanuman Books, New York, 1991. Bellamy won the 2002 Firecracker Alternative Book Award for poetry with her 2001 book *Cunt-Ups*, Tender Buttons, New York.

NAYLAND BLAKE, page 72

Whether working as an artist, writer, educator, or curator, Nayland Blake explores how identities are constructed and how stereotypes may be disrupted. Blake is an AIDS activist, and illness is a recurring subject in his work. In many of his drawings, a rabbit represents prejudices about homosexual promiscuity; it also relates to the African American folk hero of the Uncle Remus tales and, by extension, to Blake's own mixed ethnicity. In large physical structures such as a gingerbread log cabin, or gestures such as tap dancing in a bunny suit altered to make the artist weigh the same as his lover or being fed copious amounts of food by a shirtless man, Blake satirizes and subverts assumptions related to race, sexual identity, codependency, dominance, and monogamy.

Blake was born in Manhattan in 1960 and studied at Bard College in New York and the California Institute of the Arts, Valencia. He lives and works in New York City. He has exhibited his work in solo and group exhibitions at Gallery Paule Anglim, San Francisco (2011); the Whitney Museum of American Art, New York (2011); the Hammer Museum, Los Angeles (2010); and the Richard L. Nelson Gallery, University of California, Davis (2010), as well as in the 45th Venice Biennale (1993) and the Whitney Biennial, New York (1991). Blake received the SECA Art Award from the San Francisco Museum of Modern Art in 1988. He is represented by Matthew Marks Gallery, New York, and Gallery Paule Anglim, San Francisco.

JENNIFER BORNSTEIN, page 36

Jennifer Bornstein's use of photography, film, sculpture, and printmaking is unified by an interest in the documentary, representational, and performative possibilities of each medium. She is drawn as well to obsolete processes and technologies—from intaglio to 16mm film—less for irony or anachronism than to push their technical limitations, and her level of skill, to productive ends. She has satirized the seduction of accumulating commodities in American consumer culture by exaggeratedly enacting it in her work. Adopting a quasi-ethnographic or pseudo-anthropological view of culture, Bornstein has observed and represented average people and situations as well as cultural figures in an overtly cartoonish style to humorously reflect on private and public life.

Bornstein was born in Seattle in 1970 and studied at the University of California, Berkeley and Los Angeles, before attending the Whitney Museum Independent Study Program in New York from 1996 to 1997. She lives and works in Berlin. Her work has been exhibited in solo and group exhibitions at DAAD, Berlin (2011); Nottingham Contemporary, Nottingham (2010); and Gavin Brown's enterprise, New York (2009), as well as in the 2nd Torino Triennial, Turin (2008), and the Biennale d'art contemporain le Havre (2008). She has been the recipient of many awards, including the DAAD Fellowship, Berlin (2010), and the Pollock-Krasner Foundation Award (2008). She is represented by Gavin Brown's enterprise, New York; greengrassi, London; and Blum and Poe Gallery, Los Angeles.

ANDREA BOWERS, page 142

Andrea Bowers's body of work includes video, drawings, textiles, and other media—each specifically attached to her political positions and general belief in art as an instigator of social justice. For example, if Bowers depicts a landscape, her interest is rooted not solely in aesthetic representation, but also in how that space may have become a geographic marker representing human and environmental exploitation by corporations. Likewise, many of the people that figure in her drawings are charged subjects, such as protesters or immigrants crossing the U.S.-Mexico border. Most often rendered in graphite on paper, these are conceived of as monuments, though far more ephemeral than bronze or stone; in them, Bowers's meticulous, photorealistic style humanizes those otherwise represented only statistically.

Bowers was born in Wilmington, Ohio, in 1965 and studied at the California Institute of the Arts, Valencia. She lives and works in Los Angeles. She has exhibited her work at the Drawing Center, New York (2011); Museum of Contemporary

Art, Los Angeles (2010); the New Museum, New York (2010); Museum of Contemporary Art, Sydney (2010); the Whitney Museum of American Art, New York (2008); Secession, Vienna (2007); the Power Plant, Toronto (2007); and Museum für Gegenwartskunst, Siegen, Germany (2007), as well as in the Whitney Biennial, New York (2004). She is represented by Susanne Vielmetter Los Angeles Projects and Andrew Kreps Gallery, New York.

ROBERT BUCK, page 60

Robert Buck uses a variety of matter in his installations, paintings, sculptures, and collages, and the works tend to carry textual references to the origins of each component, written or printed on their surface. Along with such traces of the artist's hand, Buck often shows the underlying grid, be it the digital checkerboard or the pencil lines that aid in his renderings; in his more palimpsestic works he conflates and overlays imagery and text. Buck is interested in psychology and personality-assessment tests, as well as in forensics and mysterious crimes, and this can be seen in works that effectively interpret themselves. In 2008, he gave up his legal surname, Beck, and began working as Robert Buck—a gesture that at once challenges and reaffirms the presumed autonomy of authorship and artistic agency.

Buck was born in Baltimore, Maryland, in 1959 and attended the Tisch School of the Arts at New York University and the Independent Study Program of the Whitney Museum of American Art, New York. He lives and works in New York City. His work has been exhibited in solo and group exhibitions at Bertrand Delacroix Gallery, New York (2011); Salomon Contemporary, New York (2010); Lehmann Maupin, New York (2010); and Anthony Meier Fine Arts, San Francisco (2009), among many others. He is represented by CRG Gallery, New York, and Stephan Friedman Gallery, London.

JOHANNA CALLE, page 75

Johanna Calle often approaches drawing from a textual perspective, extending toward abstraction the strategies and traditions of concrete poetry, cryptography, conceptual art, compositional notation, asemic writing, and the ebullient ornamentation of calligraphy. Throughout her practice, Calle uses the aesthetics and application of cursive writing in conjunction with more economical transcription methods, such as shorthand, to comment on social issues through both narrative and reference. At once highlighting and

redacting information in this way, Calle's work touches upon such themes as rootlessness, the situation of children, language, and the sociopolitical conditions of her native Colombia.

Calle was born in 1965 in Bogotá, where she still lives, and studied at the Chelsea College of Art, London. She has participated in exhibitions at venues including the 12th Istanbul Biennial (2011); Fundación Teorética, San José, Costa Rica (2008); and Galería Farías & Fábregas, Caracas, Venezuela (2007), as well as in ARCO 09 in Madrid (2009) and the 7th Bienal do Mercosul, Porto Alegre, Brazil (2009). Calle was awarded an Emerging Artists Grant by the Cisneros Fontanals Art Foundation (CIFO), Miami, in 2008. She is represented by Galería Casas Riegner, Bogotá.

MARTHA COLBURN, page 102

Martha Colburn works primarily in film, creating stop-motion animations that contend with contemporary and historical subjects, pop culture, sexuality, and violence. Her expansive tableaus combine various strategies of production—puppetry, collage, painting, assemblage—with driving musical and spoken-word scores. In early works, Colburn salvaged found footage from 16mm educational films, directly painting on and scraping into the negatives. She later began working with Super 8 to produce her singular animations. Recently she has employed mirrors to gain riotous, kaleidoscopic effects as her work becomes more hallucinatory and fragmented.

Colburn was born in Gettysburg, Pennsylvania, in 1971 and studied at the Maryland Institute College of Art, Baltimore, before attending the Rijksakademie van Beeldende Kunsten in Amsterdam. She lives and works in New York City. Her works have been exhibited at the Philadelphia Museum of Art (2009); James Cohan Gallery, New York (2009); Frans Hals Museum De Hallen, Haarlem, the Netherlands (2008); Diverse Works Art Space, Houston (2008); Art Statements, Art Basel (2008); and the Centre Georges Pompidou, Paris (2007), as well as in the SITE Santa Fe Biennial (2010) and the Whitney Biennial, New York (2006), among many others.

SAM DURANT, page 93

Sam Durant's practice conveys an interest in social and political issues, related in particular to American history and

culture—from the Black Panthers, squatters, and the genocide of Native Americans to modernist design and advertising. Durant works in various media, including drawings, sculpture, and installations with sound, as well as cartography, with specific interest in who is mapped and by whom. His work displays a preoccupation with space—particularly with architecture, monuments, civic design, and planning—but also with activism, as his projects propose alternate procedures for telling stories about neglected histories.

Durant was born in Seattle in 1961 and studied at the California Institute of the Arts, Valencia. He lives and works in Los Angeles. He has exhibited his work in institutions including the Museum of Contemporary Art, Los Angeles (2011); Serralves Museu, Portugal (2011); and the Guggenheim Museum, New York (2010), as well as in the XIV International Sculpture Biennale of Carrara, Italy (2010); the Panama Biennial (2008); and the Sydney Biennial (2008). He is represented by Blum and Poe Gallery, Los Angeles, and Paula Cooper Gallery, New York.

SHANNON EBNER, page 47

Whether working in photography or sculpture, Shannon Ebner uses text as a primary material. She transposes words through the figurative language of landscape photography, the graphic cues of propaganda, and the physiognomic and semantic qualities of typography. Using simple display armatures such as those found in a hardware store, in conjunction with concrete cinderblocks, paint, paper, and tape, Ebner has created a malleable alphabet and, from it, a variety of word forms in photographs, books, and serigraphs. Appropriating materials (as well as cannibalizing her own), Ebner generates new meaning through the construction, reconstitution, and revelation of messages. Her practice is, like an asterisk, a process of redirecting attention to the complex lattice of messages we inhabit and construct.

Born in Englewood, New Jersey, in 1971, Ebner studied photography at Bard College in New York and at Yale University. She lives and works in Los Angeles. She has exhibited her work in group and solo exhibitions at the Walker Art Center, Minneapolis (2011); Altman Siegel Gallery, San Francisco (2010); Wallspace, New York (2009); and P.S.1 Contemporary Art Center, Long Island City, New York (2007), as well as in the VI Berlin Biennial for Contemporary Art

Artists and Poets

(2010) and the Whitney Biennial, New York (2008). Ebner was the 2010 recipient of the Rencontres d'Arles Discovery Award. She is represented by Wallspace Gallery, New York, and Altman Siegel Gallery, San Francisco.

KARI EDWARDS, page 136

For kari edwards, "language is a tool that can be used and then destroyed or re-used again in a different way."[5] Her poetry often deals with gender construction and refutes notions of a fixed identity through seamless movements between genres, and between autobiography and fiction. The result is writing that is critical and dreamlike, metatextual, referential, and subversive. Having spent considerable time in India and studying Buddhism, edwards edged her poetry into mystical and metaphysical realms, at the same time rooting it in an amplified lived experience.

Born in Illinois, edwards (1954–2006) studied writing and contemplative psychology at the Naropa Institute, Boulder, Colorado. Her writing has appeared in numerous publications, including the anthologies *Civil Disobedience: Poetics and Politics in Action*; *Blood and Tears: Poems for Matthew Shepard*; *Bisexuality and Transgenderism: InterSEXions of the Others*; and *Electric Spandex: anthology of writing the queer text*. Her many books include *having been blue for charity*, BlazeVox, Buffalo, New York, 2006; *iduna*, O Books, Brooklyn, New York, 2004; and *Bharat jiva*, posthumously published in 2009 by Litmus Press/Belladonna Books, New York. In 2002 she received the New Langton Arts Bay Area Award in literature.

NICOLE EISENMAN, page 138

Nicole Eisenman has worked in animation, drawing, installation, and painting to respond to varied historical and philosophical concerns while reflecting on her own orientation within the world. Her paintings are filled with reference and symbolism, which can be read through the posture and clothing of the people she depicts, who appear disfigured or abstracted within odd social scenes and settings. Indeed, they seem stoic, and, whether alone or in groups, are generally masked, isolated, marginalized, depressed. There are antic and melancholic qualities to Eisenman's work, which is made more strange by surprising humor in her embedding of subtle signs into the appearance of her characters—out-turned pockets, top hats, bestial features, distorted or misplaced appendages—and the leading cues provided in her titles.

Eisenman was born in Verdun, France, in 1965 and studied at Rhode Island School of Design, Providence. She lives and works in New York City. Her work has been included in solo and group exhibitions at numerous institutions and galleries including Susanne Vielmetter Los Angeles Projects (2011 and 2007); Galerie Gregor Staiger, Zurich (2011); The Jewish Museum, New York (2010); Leo Koenig, Inc., New York (2010 and 2009); Museo de Arte Contemporáneo de Vigo, Spain (2009); Kunstmuseum Luzern (2008); Frac Île-de-France, Paris (2007); and Kunsthalle Zürich (2007). She is represented by Leo Koenig, Inc., New York, and Susanne Vielmetter Los Angeles Projects.

SIMON FUJIWARA, page 97

Simon Fujiwara produces works that tread the line between fiction and nonfiction, while showing that distinction to be a false dichotomy. He often adopts a pseudo-anthropological guise in creating site-specific projects that take a variety of forms. These have included cello performances with slide shows, theatrical plays, fictional collections of artifacts and concocted evidence, letters translated phonetically, performative video interviews, and an installation centered on his process of writing an erotic novel. Fujiwara frequently deals with themes of sexual repression, homophobia, and the impossibility of a single or fixed personal identity. At the same time he raises ontological questions through a conflation of autobiography and wholly imaginative constructions—in words, gestures, and objects alike.

Born in London in 1982, Fujiwara studied fine art at the Staatliche Hochschule für Bildende Künst in Frankfurt am Main and architecture at Cambridge University. He divides his time between Berlin and Mexico City. His work has appeared in solo and group exhibitions at museums and galleries including the Singapore Biennial (2011); the Bienal Internacional de São Paulo (2010); *Manifesta* 8 (2010); *Performa* 11 (2010), and the 53rd Venice Biennale (2009). In 2010 he was awarded the Cartier Award and the Baloise Art Prize. His work will be presented in a solo exhibition at Tate St. Ives in 2012. He is represented by Neue Alte Brücke, Frankfurt.

LIAM GILLICK, page 88

Liam Gillick's work taps into Minimalism and twentieth-century modernist design, made evident in the gridded, Plexiglas and aluminum public sculptures that he frequently produces. His practice, however, extends into a wide range of materials and strategies, which have included furniture, architecture, books, films, text, sound, even a talking taxidermied cat. Gillick is also interested in interpersonal exchanges and how space, particularly the built environment, influences those relations. Making art collaboratively, organizing exhibitions, and extensively publishing critical writing, Gillick works fluidly across disciplinary lines.

Gillick was born in Aylesbury, England, in 1964 and studied at the Hertfordshire College of Art, Hatfield, and Goldsmiths College, London. He currently lives and works in New York City. His work has been exhibited in solo and group exhibitions at the Museum van Hedendaagse Kunst Antwerpen, Antwerp (2011); Air de Paris, Paris (2011); Casey Kaplan, New York (2010); and the Museum of Contemporary Art Chicago (2010), as well as in the 8th Shanghai Biennale (2010) and the 53rd Venice Biennale (2009), representing Germany. He is represented by Casey Kaplan Gallery, New York.

ROBERT GOBER, page 140

For more than three decades, Robert Gober has been developing a complex lexicon of iconography—from domestic objects, like sinks and cat litter, to churches and fragmented body parts. Gober's practice encompasses highly realistic beeswax sculptures (a man's leg protruding from the wall, for example), linoleum-block prints, slide shows, paintings, and newspaper works. Muted, sometimes even melancholic, much of Gober's art is oblique enough to be interpreted in many different ways, yet it is charged with references to violence, racism, homophobia, and other challenging topics. The ambiguity of his work is heightened by the way in which he defamiliarizes common images and objects.

Gober was born in Wallingford, Connecticut, in 1954 and studied at Middlebury College in Vermont and the Tyler School of Art in Rome. He lives and works in New York City. His work has been exhibited at the Walker Art Center, Minneapolis (2011); Centre Georges Pompidou, Paris (2011); and the Museum of Modern Art, New York (2010), as well as in five Whitney Biennials and the 49th Venice Biennale (2001), where he represented the United States. Projects as

curator include *Heat Waves in a Swamp: The Paintings of Charles Burchfield*, the Hammer Museum, Los Angeles (2010), and *The Meat Wagon*, the Menil Collection, Houston (2005). He had a retrospective at Shaulager, Basel, in 2007. He is represented by Matthew Marks Gallery, New York.

ANN HAMILTON, page 81

Ann Hamilton makes site-specific, immersive installations drawing on a multitude of media. Her work variously incorporates sculpture, photography, textiles, poetry, video, sound, found objects, spoken word, and repeating performative gestures. The resultant complexly structured environments often provoke strong reactions and metaphorical associations to form layered meanings. Hamilton invokes time, language, found materials, and memory in response to the architectural presence and social history of her selected sites. As she summons the past through considered formalizations of labor in the present, she collapses the distance between immediate emotional experience and what is lost in the passage of time.

Hamilton was born in Lima, Ohio, in 1956 and studied at the University of Kansas and the Yale University School of Art. She lives and works in Columbus, Ohio. Her work has been included in solo and group exhibitions internationally, and she was the U.S. representative at both the 48th Venice Biennale (1999) and the 21st Bienal Internacional de São Paulo (1991). She has completed numerous permanent commissions. She received the United States Artists Fellowship (2007), the Environmental Design Research Association Place Design Award (2002), and the Guggenheim Memorial Fellowship (1989), among many other distinctions.

SHARON HAYES, page 51

Through public performances, videos, and installations, Sharon Hayes reactivates forms of communication, particularly strategies of dissent, used in the twentieth century (1970s gay rights slogans, for example) to see how they operate in the present. In this context she works in the areas of anthropology, film, journalism, linguistics, and theater. With particular attention to the construction of gender and sexuality in the articulations of political protest, Hayes stages provocative situations in specific contexts, such as an LGBT chorus at the Democratic National Convention. Yet these are not so much reenactments as rearticulations and modes of resistance, where past gestures become frameworks for direct intervention in human relations and reactions, history and potential.

Hayes was born in Baltimore, Maryland, in 1970 and studied at the University of California, Los Angeles, and the Whitney Museum of American Art Independent Study Program, New York. She lives and works in New York City. Her work has been exhibited at the Museum Reina Sofia, Madrid (2011); the Museum of Modern Art, New York (2010); the Museum of Modern Art, Warsaw (2008); the Generali Foundation, Vienna (2007); and Tate Modern, London (2007), as well as in the Whitney Biennial, New York (2010); *Frieze Projects*, London (2008); and *Documenta* 12, Kassel (2007). She is represented by Tanya Leighton Gallery, Berlin.

CHRISTIAN HOLSTAD, page 127

Labor abounds in Christian Holstad's practice, as a strategy and a concern. While an interest in craft is particularly evident in his crocheted soft sculptures (such as an array of sagging shopping carts), a tendency toward craftsmanship can be seen in all of his sculptural objects. Whether working with jukeboxes, mixed-media quilts, or nativity donkeys, Holstad attends to American consumer culture. He also creates collages in which homoerotic figures often appear in suggestive sexual poses, but are depicted through abstraction and erasure, as absences or silhouettes. Holstad prefers alternative spaces; he transformed an abandoned deli in downtown New York, renaming it Leather Beach—a reference to the city's gay leather culture before the AIDS crisis.

Born in Anaheim, California, in 1972, Holstad studied at the Kansas City Art Institute. He lives and works in New York City. He has exhibited his work in solo and group exhibitions at Schmidt & Handrup Gallery, Cologne (2010); Daniel Reich Gallery, New York (2009); Galleria Civica di Modena, Italy (2009); the Museum of Modern Art, New York (2009); Victoria Miro Gallery, London (2008); the New Museum of Contemporary Art, New York (2008); Galleria Massimo De Carlo, Milan (2006); Museum of Contemporary Art, Miami (2006); and Kunsthalle Zürich (2004), as well as in the Biennale de Lyon, France (2007); the Moscow Biennial of Contemporary Art (2007); *Performa 05*, New York (2005); and the Whitney Biennial, New York (2004). He is represented by Victoria Miro Gallery, London.

ELLIOTT HUNDLEY, page 32

Working in collage, painting, photography, and combinations of these media that result in sculptural forms, sometimes suspended from the ceiling, Elliott Hundley creates enigmatic compositions that can be read in multiple ways. He combines personal references with citations from mythology, art history, and philosophy, resulting in hints of narrative. By colliding antiquity with modernity, his pan-historical appropriation amplifies the eclectic materials he agglomerates into signs, ideas, and denaturalized matter. Hundley often uses scale to his advantage as well, creating reliefs and paintings that appear differently at various distances, such that up close the whole appears to break up into the thousands of parts that comprise it.

Hundley was born in Greensboro, North Carolina, in 1975 and studied at Rhode Island School of Design, Providence; the Skowhegan School of Painting and Sculpture, Madison, Maine; and the University of California, Los Angeles. He lives and works in Los Angeles. His work has been included in solo and group exhibitions at the Wexner Center for the Arts, Columbus, Ohio (2011); Galleria il Capricorno, Venice (2010); the Guggenheim Museum, New York (2010 and 2007); and the New Museum of Contemporary Art, New York (2010 and 2007); and the Hammer Museum, Los Angeles (2006). He is represented by Regen Projects, Los Angeles, and Andrea Rosen Gallery, New York.

COLTER JACOBSEN, page 39

Colter Jacobsen works with photography, installation, assemblage, and drawing. In pencil drawings on paper, he uses his uncanny capacity for memorization to exploit the subtle failings and exaggerations of memory—how it produces both loss and invention. Reproducing found images with implicit references or suggestive allusions, first from a source and then solely from memory, results in image pairings that themselves demonstrate an impressive technical ability. Yet the resemblance and slippage from one image to the next also creates a certain friction, engendering a sense of displacement and temporal disconnection. Similarly, for larger-scaled assemblages, Jacobsen procures discarded, or "lost," matter from the urban environment,

Artists and Poets

which he then positions with drawings or paintings to create suggestive constellations of matter.

Jacobsen was born in Ramona, California, in 1975 and studied at the San Francisco Art Institute. He lives and works in San Francisco. His work has been shown in galleries and museums throughout the United States and Europe, with recent exhibitions at Corvi-Mora, London (2011); Galerie Krinzinger, Vienna (2010); LA><ART, Los Angeles (2010); the CCA Wattis Institute for Contemporary Art, San Francisco (2009); and White Columns, New York (2008). Most recently, Jacobsen was one of SFMOMA's 2010 SECA Art Award recipients. He is represented by Corvi Mora, London.

MATT KEEGAN, page 29

In his practice, Matt Keegan draws on strategies introduced in conceptual art, but he balances straightforward dryness with subtle humor and, often, an equally subtle social element. Although he primarily produces photography, he also creates publications and curates exhibitions. One of Keegan's series is titled *Images are words*, and the inverse could be said for his handling of textual elements, whether invented or appropriated; it seems that names are no more nor less representations than photographs. Erasure and extraction surface as common themes and tactics throughout. An interest in time punctuates his work as well: he has titled pieces after specific days and months, depicted calendars, listed the days of the week, and unearthed a relative's archive, resituating it in the present.

Keegan was born in Manhasset, New York, in 1976 and studied at Carnegie Mellon University, Pittsburgh; Skowhegan School of Painting and Sculpture, Madison, Maine; and Columbia University, New York. He lives and works in New York City. His work has been included in solo and group exhibitions at Aspen Art Museum, Colorado (2011); D'Amelio Terras, New York (2011); Neon Parc, Melbourne (2010); the Guggenheim Museum in Bilbao, Spain (2010); the Guggenheim Museum, New York (2010); and Altman Siegel Gallery, San Francisco (2009). He is represented by Altman Siegel Gallery, San Francisco, and D'Amelio Terras, New York.

KEVIN KILLIAN, page 58

A key member of the New Narrative circle, Kevin Killian is a prolific poet. His expository writing often deals with sexuality and desire through a conflation of autobiography and fiction, using allegory, allusion, camp, and dark humor. According to Jacques Khalip, Killian's poetry attempts to "move beyond simple identifications with social reality and towards more extensive, multiple relations with a culture of imaginative dispossession."[6] Genre boundaries are regularly tripped and collapsed in Killian's expanded practice—he is a novelist, playwright, curator, and cultural critic.

Born in Long Island, New York, in 1952, Killian studied at State University of New York at Stony Brook. He lives and works in San Francisco. His books include the short story collection *Impossible Princess*, City Lights, San Francisco, 2009, which won the 2010 Lambda Literary Award for best gay erotic fiction; the poetry collection *Action Kylie*, ingirumimusnocteetconsumimurigni, New York, 2008; *Argento Series*, Krupskaya, San Francisco, 2001, written in response to the AIDS crisis; and *Little Men*, Hard Press Editions, Lenox, Massachusetts, 1996. Also a celebrated editor, in 2008 Killian co-edited (with Peter Gizzi) *My Vocabulary Did This to Me: The Collected Poetry of Jack Spicer*, which won the American Book Award for poetry in 2009. In 2010 he published *The Kenning Anthology of Poets Theater 1945–1985*, co-edited with David Brazil.

CARLOS MOTTA, page 131

Working primarily in photography and video installation, Carlos Motta uses strategies from documentary film, sociology, and public demonstrations to offer accounts of overlooked histories and to give voice to oppressed communities. Whether in the form of surveys, interviews, or performative actions in public squares, Motta's topical subjects are as diverse as the effect of U.S. foreign policies in Latin America (as in his project *The Good Life*), LGBTQ politics across the world (as in *We Who Feel Differently*), or the violent political history of his native Colombia.

Motta was born in Bogotá in 1978 and studied at the School of Visual Arts, Bard College, and the Whitney Museum of American Art Independent Study Program, both in New York. He lives and works in New York City. Motta has shown his work at the Guggenheim Museum, New York (2011); Wiener FestWochen, Vienna (2011); the San Francisco Art Institute (2010); and the Museo de Arte del Banco de la República, Bogotá (2010), as well as in the Moscow International Biennale for Young Art (2010) and the 10th Biennale de Lyon, France (2009). He is the recipient of numerous grants and awards, including a Guggenheim Fellowship in 2008.

CATHERINE OPIE, page 142

In her practice, Catherine Opie interprets the discipline of documentary photography from a contemporary perspective. She questions what constitutes an American identity, as seen through portraits and landscapes portraying seemingly disparate communities—football players, ice fishers, surfers, queer people. She has a keen interest in natural and built, urban and suburban geographies. Whether the subject is banal or grotesque, a high level of formalism and a honed attention to aesthetics are evident throughout her work, along with an interest in civil rights, gender identity, and the marginalization of minorities.

Opie was born in Sandusky, Ohio, in 1961 and studied at the San Francisco Art Institute and the California Institute of the Arts, Valencia. She lives and works in Los Angeles. Opie has had solo exhibitions in galleries and museums including the Institute of Contemporary Art, Boston (2011); Peder Lund, Oslo (2011); the Los Angeles County Museum of Art (2010); and a retrospective at the Guggenheim Museum, New York (2008). Her work was included in the 2nd International Biennial of Contemporary Art, Seville, Spain (2006); the 26th Bienal Internacional São Paulo (2004); and the Whitney Biennial, New York (2004 and 1995).

NICOLÁS PARIS, page 113

Through drawing, Nicolás Paris tests the limits of representation. He pays particular attention to the simultaneity of images and ideas, and how both may be spread through different media. In his 2008 artist's book *DOBLEFAZ* (a facsimile publication reproducing an eponymous series of drawings), changes in the surface of the paper make the pages supporting these inscriptions seem as important as the drawings themselves. Paris is engaged in a parallel discursive practice, producing educational projects and drawing laboratories in support of teaching departments and bolstering curriculum development for educational institutions. By these means he elaborates drawing's role as a visionary tool, not solely a means of representation.

Paris was born in 1977 in Bogotá, Colombia, where he still lives. He studied architecture at the Universidad de los Andes. In addition to participating in biennials

including the 54th Venice Biennale (2011) and the 7th Bienal do Mercosul, Porto Alegre, Brazil (2009), he has exhibited his work at Kurimanzutto, Mexico City (2010), and the Museo de Arte Contemporáneo de Castilla y León (MUSAC), Spain (2010). MUSAC awarded him a scholarship for artistic creation in 2007–8. In 2006 he won the acquisition prize from the Colección Banco BBVA Colombia at the Salón de Arte BBVA.

DAN PERJOVSCHI, page 63

Dan Perjovschi's signature marker drawings exist somewhere between graffiti and cartoons. Composed of images and texts, they are often applied directly onto architectural surfaces, whether in galleries or on the street. Perjovschi favors immediacy over verisimilitude, and this allows him to satirize complex social and political issues quickly, simply, and with a trenchant economy of means. By creating his work publicly or during the open hours of the exhibiting institution, Perjovschi makes his process available to viewers, who may in turn feel more integrated, if not implicated, as he responds to specific contexts and events, including the exhibition site, its institutional history, the local and international sociopolitical context, and, sometimes, his own biography.

Perjovschi was born in Sibiu, Romania, in 1961 and studied painting at the George Enescu University of Arts in Iași, Romania. He lives and works in Sibiu and Bucharest. His work has appeared in institutions worldwide, including the San Francisco Art Institute (2010); Centre Georges Pompidou, Paris (2010 and 2007); the Museum of Modern Art, New York (2007); and Tate Modern, London (2006), as well as in the 10th Biennale de Lyon, France (2009); the Sydney Biennial (2008); and the 52nd Venice Biennale (2007). He was the recipient of the George Maciunas Award (2004) and the Henkel CEE Prize for Contemporary Drawing (2002). He is represented by Lombard-Freid Projects, New York.

RAYMOND PETTIBON, page 56

Raymond Pettibon's watercolors and ink drawings collide imagery and text in an ironic commentary on American popular culture—sports, religion, politics, sexuality, and, of course, music. Known for the iconic album covers, flyers, and other ephemera he produced for Black Flag, The Minutemen, Sonic Youth, and other bands during the 1980s, Pettibon has since expanded his practice to include video, featuring animations and live-action films with original scripts. He has also created installations, extending his drawings directly onto the walls of the exhibition space. As a collector of fragmented quotations, clippings, signs, and stories, Pettibon produces art through critical recombination, inspired as much by the literary work of Mickey Spillane, Marcel Proust, and Samuel Beckett as by Francisco de Goya's drawings and engravings.

Born in Tucson, Arizona, in 1957, Pettibon studied economics at the University of California, Los Angeles, and lives and works in Los Angeles. His work has appeared in solo and group exhibitions including the Museum of Contemporary Art, Los Angeles (2010); the Whitney Museum of American Art, New York (2010 and 2005); the Barbican Art Gallery, London (2007); and the Centre Georges Pompidou, Paris (2006), and in biennials including the 12th Istanbul Biennial (2011); the California Biennial (2008); the 52nd Venice Biennale (2007); and *Documenta* 11, Kassel (2002). He is represented by Regen Projects, Los Angeles, and David Zwirner Gallery, New York.

ARIANA REINES, page 118

Through her deceptively straightforward poetry, Ariana Reines uses personal biography as lyric substance. Navigating first- and second-person narrativity, she frequently integrates tropes, such as love poetry, filtered through seemingly abject, violent, and sexual subjects. Reines has stated, "I try to embarrass myself on purpose,"[7] and as preemptive strategies her self-effacement and attempts at productive failure are confrontational and empowering gestures.

Reines was born in Salem, Massachusetts, and studied at Barnard College and Columbia University, New York, and The European Graduate School. Her work has appeared in a variety of publications, including the anthologies *Against Expression* and *Gurlesque*. Her more recent books include *Mercury*, FenceBooks, 2011; *Coeur de Lion*, self-published by Mal-O-Mar in 2007 and reissued in 2011 by Fence; and *Save the World*, Mal-O-Mar, 2010. Her critically acclaimed play, *Telephone*, commissioned by the Foundry Theatre, was presented in 2009 at the Cherry Land Theatre, New York. Reines has performed widely, including in the Works & Processes series at the Solomon R. Guggenheim Museum, New York, and was a Virginia C. Holloway Lecturer in Poetry at the University of California, Berkeley, in 2009.

AMY SILLMAN, page 106

In her practice, Amy Sillman employs the anti-classical procedures of Abstract Expressionism without that movement's austerity, grandeur, or spiritual aspirations. Working more irreverently, she takes the postwar period of art production as one of her subjects. Sillman couples references to Ab-Ex with diagrammatic strategies, used as rhetorical devices, to articulate potential connections between disparate sets of relations. Although her extensive body of work is informed by philosophy, psychoanalysis (particularly free association techniques), film, and feminism, Sillman's output is not academic. Rather, her paintings contain a provocative humor. Neither parody nor tribute, they open up a space for dissociative junctures, accidents, overlaps, coincidences, inference, and mistranslation.

Sillman was born in Detroit, Michigan, in 1966 and studied at the School of Visual Art and Bard College, both in New York. She lives and works in New York City. She has exhibited her work at the Institute of Contemporary Art, Boston (2011); Harris Lieberman, New York (2011); the Orange County Museum of Art, Newport Beach, California (2010); Carlier / Gebauer, Berlin (2009); and Prospect.1, New Orleans (2008/2009). She has forthcoming exhibitions at the Henry Art Gallery, Seattle (2012); the Miami Art Museum, Florida (2012); and the Nasher Museum of Art at Duke University, Durham, North Carolina (2013). She is represented by Sikemma, Jenkins, and Co., New York, and Susanne Vielmetter Los Angeles Projects.

ALLISON SMITH, page 116

Allison Smith recalls the past to reinvigorate the present. Primarily working as a sculptor, she produces work pervaded by an interest in craft—the techniques and materials embedded in objects, and the specific histories carried within those aesthetic and mnemonic forms. The personal exchanges that took place in general stores, the intergenerational skill sets passed down and evinced in nineteenth-century decorative arts, roadside recruiting stations, and other forms of material and social exchange are anachronistically represented in her projects. Smith often works collaboratively, engaging others while drawing from historical models (Civil War reenactments, mercantile hawkers, and so on), and conducting workshops or organizing public events, performances, and skills exchanges.

Smith was born in Manassas, Virginia, in 1972 and studied at the New School

for Social Research, New York; Parsons School of Design, New York; the Yale University School of Art, New Haven, Connecticut; and the Whitney Museum Independent Study Program, New York. She lives and works in San Francisco. Her work has been included in solo exhibitions at Southern Exposure, San Francisco (2011); the Museum of Contemporary Art, Denver (2011); the San Francisco Museum of Modern Art (2010); Mildred Lane Kemper Art Museum, St. Louis, Missouri (2010); the Indianapolis Museum of Art (2008); and the University of California, Berkeley Art Museum and Pacific Film Archive (2007), among others. She is represented by Cheryl Haines Gallery, San Francisco.

LILY VAN DER STOKKER,
page 110

In bright iridescent colors, Lily van der Stokker creates large-scale wall paintings and floor pieces with a cartoonish quality. The artist depicts tropes such as friendship, family, exuberance, and optimism, which, although perhaps highly accessible to a general public, might be considered clichéd in contemporary art. Through this subversive gesture, she questions the very attributes to which her work might seem reducible, at least on a surface level—prettiness, triteness, campiness, garishness, or immaturity. Moreover, by skirting any single, overt meaning or specific set of references, the scribbled notations and graphic elements in her work remain opaque, and this uncertainty is exaggerated by the decorative appearance and banality of her forms.

Van der Stokker, born in Den Bosch, the Netherlands, in 1954, lives and works in Amsterdam and New York. Her work has been exhibited in solo and group exhibitions at Tate St. Ives (2010); Museum Boijmans van Beuningen, Rotterdam (2010 and 2009); Musée des Beaux-Arts de la Ville de La Chaux-de-Fonds, Switzerland (2010); Le Magasin, Grenoble, France (2009); Centro di Ricerca Arte Attuale, Villa Giulia, Italy (2009); Musée d'Art Contemporain, Bordeaux, France (2008); and De Appel, Amsterdam (2008), among many others. She is represented by Leo Koenig, Inc., New York.

ERIKA VOGT, pages 47 and 100

Through sculptures, collages, projections, chromogenic prints, and films, Erika Vogt engages in the production of images. She frequently transposes digital and analog media. Vogt's video works depict multilayered, disjunctive spaces, where medium specificity is dissolved and narratives are alluded to without relying on traditional filmmaking devices, such as scripts, cast, crew, scenography, or lighting. Vogt presents a range of ambiguous and symbolic, often self-reflexive imagery—levitating oil trucks or inflating tires, dice reflected in a parallax view via angular mirror constructions, or projected videos of projected films.

Vogt was born in Newark, New Jersey, in 1973 and studied at New York University and the California Institute of the Arts, Valencia. She lives and works in Los Angeles. Her work has been exhibited at venues including Overduin and Kite, Los Angeles (2010); the Henry Art Museum, Seattle (2010); the Hammer Museum, Los Angeles (2007); the Frieze Art Fair, London (2006); Centre Georges Pompidou, Paris (2006); and the Museum of Modern Art, New York (2006), as well as in the Whitney Biennial, New York (2010), and the 2008 California Biennial, at the Orange County Museum of Art, Newport Beach. She is represented by Overduin and Kite, Los Angeles.

ANNE WALDMAN, page 79

Associated with the Beat, New York School, and Outrider movements of the New American Poetry, Anne Waldman has performed her own poems in venues worldwide—an act she considers a "ritualized event in time."[8] Political awareness and social consciousness permeate her expansive body of work, which extends to writing, teaching, editing, performing, and cultural activism. She has been a student of Tibetan Buddhism and Indonesian oral and musical traditions, and in her poems she combines vivid imagery and an attentive concern for sound with linguistic experimentation. In performance, a palpable energy is transferred via her unique cadence and a combination of breathing, chanting, physical movements, and singing.

Waldman grew up in New York City and received her BA from Bennington College, Vermont. She was one of the founders of The Poetry Project at St. Mark's Church in-the-Bowery. In 1974 she cofounded, with Allen Ginsberg, the Jack Kerouac School of Disembodied Poetics at Naropa University, Boulder, Colorado, and she is the artistic director of its celebrated Summer Writing Program. She lives and works in New York and Boulder. Her more than forty books include *The Iovis Trilogy:*

Colors in the Mechanism of Concealment, Coffee House Press, Minneapolis, 2011; *Manatee / Humanity,* Penguin Poets, New York, 2009; and the play *Red Noir,* Farfalla, McMillen, Parrish, Boulder, 2007, which was produced by The Living Theatre in 2010–11. Waldman has received the Poetry Society of America's Shelley Memorial Award and grants from the Foundation for Contemporary Performance Arts, the National Endowment for the Arts, and the Poetry Foundation. She has collaborated on projects with visual artists Elizabeth Murray, Richard Tuttle, and Pat Steir, choreographer Douglas Dunn, and composers Steven Taylor and Ambrose Bye, and has cowritten film scripts with her husband, the writer and filmmaker Ed Bowes. She is a Chancellor of the Academy of American Poets.

*

[1] Marvin Gladney, *"Brief Capital of Disturbances:* Poems by George Albon," *Double Room: A Journal of Flash Fiction and Prose Poetry* 4 (Spring/Summer 2004), http://www.webdelsol.com/Double_Room/issue_four/George_Albon.html.

[2] Harryette Mullen, "'A Collective Force of Burning Ink': Will Alexander's *Asia & Haiti,*" *Callalloo,* Spring 1999: 417.

[3] Helen McNeil, "Between Brass and Silver," *Times Literary Supplement,* June 5, 1981, 644.

[4] Bruce Benderson, quoted in Dodie Bellamy, *Academonia* (San Francisco: Krupskaya, 2006), back cover.

[5] Akilah Oliver, "Shifting the Subject: An Interview with kari edwards," *Rain Taxi,* Spring 2003, http://www.raintaxi.com/online/2003spring/edwards.shtml.

[6] Jacques Khalip, "Suspirias: Kevin Killian's Argento Series," *Titanic Operas: Poetry and New Materialities,* http://www.emilydickinson.org/titanic/material/khalipkillian.html.

[7] Video documentation of Reines's appearance at Timken Hall, California College of the Arts, San Francisco, September 10, 2010, http://www.youtube.com/watch?v=JoWJpJLAjT4.

[8] Anne Waldman, "Anne Waldman: 1945–," *Contemporary Authors Autobiography Series,* Gale Research Series 17 (1993): 280.

Acknowledgments

The realization of this book owes to the incredible generosity of David Teiger and the Teiger Foundation, which funded the *Air We Breathe* project in addition to offering the inspirational license to think creatively. I am grateful to John Silberman and the Annalee Newman Fund of The New York Community Trust for providing additional enabling support. Director Neal Benezra's encouragement bolstered the project from the outset. I am particularly appreciative of the wisdom and advocacy that Gary Garrels, Elise S. Haas Senior Curator of Painting and Sculpture, proffered at every step of the process.

Uniquely, the project originated as a book before it became an exhibition. The success of this publication is largely due to SFMOMA's Publications Department; both Chad Coerver and Judy Bloch brought depth and character to the catalogue. The elegant and impactful design was created by Geoff Kaplan of General Working Group, whose overall insight and humor were indelible assets. Erin Hyman and Juliet Clark aided in image gathering and proofreading, respectively. Susan Backman and Don Ross capably and generously handled the imaging for a majority of the works presented in the catalogue, and Anne Bast secured reproduction rights. I thank the artists' galleries and agents for their facilitation of the works included in this volume. The Publications Department joins me in thanking the authors—Chris Fitzpatrick, Eileen Myles, Martha Nussbaum, and Frank Rich—for their thoughtful contributions.

I deeply appreciate the innovative programming and outreach organized in conjunction with the project by my colleagues in the Education Department, in particular Dominic Willsdon, Frank Smigiel, Gina Basso, and Megan Brian, along with Suzanne Stein, who advised me on the selection of poets for the project and provided essential early support. The exhibition benefited from the expert oversight of Ruth Berson in Curatorial Affairs and of Jessica Woznak in the Exhibitions Department, with the assistance of Sarah Choi and Mia Patterson. Christina Brody adeptly handled the transport of the various works to and from locations near and far. As always, Kent Roberts and his team expertly managed the installation, and particular thanks are due to Steve Dye and Jess Kreglow. Greg Wilson and Theresa Brown framed the works on paper, and Conservator Amanda Johnson provided attentive care. I thank Robert Lasher, Libby Garrison, Robyn Wise, and Peter Denny, who brought this project to the attention of the public through media relations and community outreach, as well as Jonathan Petersen, Jennifer Mewha, Andrea Morgan, Louise Yokoi, and Sierra Gonzalez in the Development and Marketing departments. A number of interns provided valuable research and administrative support, including Sarah Bonnickson, Alex Fialho, Simone Krug, and Fabian Leyva-Barragan.

The project has gained in various ways from the feedback and support of a number of individuals: Dodie Bellamy, Janet Bishop, Vincent Fecteau, Jennifer Dunlop Fletcher, Alison Gass, Madeleine Grynsztejn, Bruce Hainley, Matthew Higgs, Jens Hoffmann, Jordan Kantor, Kevin Killian, Tina Kukielski, Pamela Lee, Trevor Paglen, Chris Perez, R. H. Quaytman, Lawrence Rinder, Julie Rodrigues-Widholm, Moira Roth, Marisa Sánchez, Stephanie Schumann, Debra Singer, Lisa Sutcliffe, and Tanya Zimbardo. Beyond the field, I am grateful to my family and for the friendship of Page Bertelsen, Maureen Boland, Dana Covello, Abigail Heald, and Yamini Kimmerle, who keep me grounded and laughing. I reserve my deepest gratitude for the artists and poets who boldly contributed to this project, amplifying our understanding of equality in the process. I salute each one of them for breathing new life into the dialogue.

Apsara DiQuinzio

About the Authors

APSARA DIQUINZIO is assistant curator of painting and sculpture at SFMOMA, where she has organized solo exhibitions with Vincent Fecteau, Mai-Thu Perret, R. H. Quaytman, Felix Schramm, and Paul Sietsema. She has contributed essays to numerous publications, including *Romanian Cultural Resolution: Contemporary Art in Romania*, *San Francisco Museum of Modern Art: 75 Years of Looking Forward*, and the 2004 Whitney Biennial exhibition catalogue.

EILEEN MYLES is a poet and writer based in New York City. She has published over twenty books of poetry, fiction and nonfiction, plays, and libretti, including *Inferno (a poet's novel)*, *Skies*, *Cool for You*, *School of Fish*, and *Not Me*. For *The Importance of Being Iceland: Travel Essays in Art* (2009) she was awarded a Warhol Foundation/Creative Capital grant. She contributes to numerous journals including *Art in America*, *Artforum*, *Parkett*, *Bookforum*, *The Nation*, and *The Believer*.

MARTHA C. NUSSBAUM is the Ernst Freund Distinguished Service Professor of Law and Ethics at the University of Chicago, appointed in the Philosophy Department, Law School, and Divinity School. Recent books include *From Disgust to Humanity: Sexual Orientation and Constitutional Law* (2010), *Not for Profit: Why Democracy Needs the Humanities* (2010), and *Creating Capabilities: The Human Development Approach* (2011).

FRANK RICH is Writer-at-Large at *New York* magazine and was an op-ed columnist at the *New York Times* from 1994 to 2011. He is the author of *The Greatest Story Ever Sold: The Decline and Fall of Truth from 9/11 to Katrina* (2006), as well as *Ghost Light: A Memoir* (2000) and *Hot Seat: Theater Criticism for* The New York Times, *1983–1993* (1998).